T0303791

CELEBRATING WAKEFIELD

PAUL L. DAWSON

AMBERLEY

First published 2023

Amberley Publishing, The Hill, Stroud
Gloucestershire GL5 4EP

www.amberley-books.com

British Library Cataloguing in Publication Data.
A catalogue record for this book is available from the British Library.

ISBN 978 1 3981 1349 7 (print)
ISBN 978 1 3981 1350 3 (ebook)

Typesetting by SJmagic DESIGN SERVICES, India.
Printed in Great Britain.

Contents

Acknowledgements

Before I begin on this odyssey, I must thank my greatly missed and valued friends Kate Taylor MBE and John Goodchild M.Univ for supporting my endeavours as a historian over twenty years ago. Kate's encouragement for a teenage lad to 'get involved' with Wakefield Historical Society, as well as her support and guidance in publishing my first essay in 'Aspects of Wakefield 2' in 1997, marked the beginning of my love affair with history, and that of my home city. John needs particular mention; we spent countless Thursdays at his office on Newstead Road talking history and about our shared faith of Unitarianism. Both Kate and John were ever ready to offer sage advice.

With this book, we look at key moments in the life of the city of Wakefield – people and events that shaped the city, and perchance the wider history of our country. Many will be critical of what I have included or omitted, but I hope there is enough of interest for all.

Paul L. Dawson

An Outline History

Like many towns and cities throughout the United Kingdom, Wakefield has evolved and changed over the last 1,000 years. Wakefield had long been regarded as the capital of the West Riding of Yorkshire since the Middle Ages, being one of the largest population centres until the late eighteenth century. The town had been a Parliamentary Borough, returning its own MP to London from 1832, and became a Municipal Borough with a mayor from 1848. In terms of commerce Wakefield was both a market town and industrial centre, the latter being based primarily on textiles, coal mining, brewing, Portland cement production, malting and engineering, as well as a thriving trade in soft drinks. The woollen trade began in the Middle Ages (as we shall see) and would become dominated during the eighteenth century by the merchant prince families of Heywood, Milnes and Naylor. In the later eighteenth century, the Holdsworth family made their fortune in the dyeing of cloth.

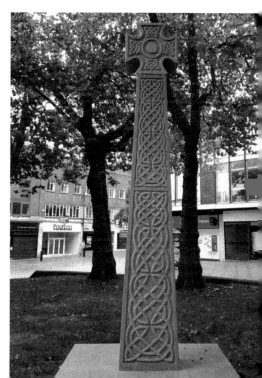

Standing outside Wakefield Cathedral, this handsome replica of the Wakefield preaching cross, erected in the ninth century, marks the heart of Wakefield.

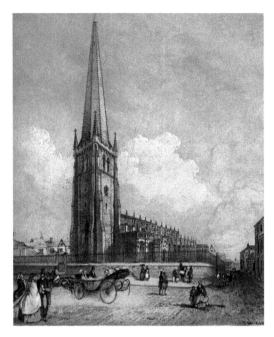

Left: Wakefield Parish Church of
All Saints, painted *c*. 1830. The
size of the church and its steeple
demonstrated the wealth of the
medieval town, made rich on the
woollen trade.

Below: Known today as the Bull
Ring, the marketplace was the
economic hub of the medieval town
of Wakefield.

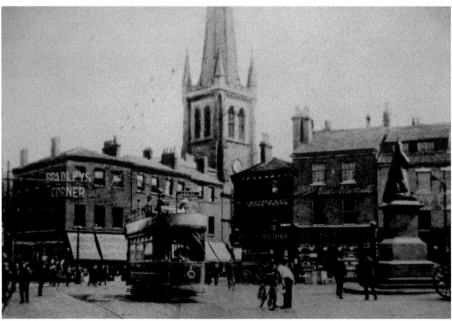

 The principal activity of the town during this period was the dressing and
finishing of woollen cloth. Undyed and unfinished cloth was sent to Wakefield
to be dyed and finished before being dispatched to London or the Continent. By
1752 Wakefield was noted for the making of worsted yarn, camblets and stuffs
(a type of worsted cloth), tammy being a type of stuff. A cloth hall specialising in

white cloth was opened in 1710 and in 1778 a Tammy Hall (or Piece Hall) was opened for the sale of tammies, white cloths and blanketing. The Tammy Hall was closed sometime after 1823 when it was let to a wool stapler, H. W. Wood, who converted the building into a stuff mill in 1829.

In 1830 it was sold as worsted manufactory for Messrs Marriott. It was they who in 1822–23 had constructed a far larger mill on Westgate Common, and a memorial to the Marriotts exists in Westgate Chapel. By 1837 the Tammy Hall was occupied by James Micklethwaite and in 1875 it was sold to Wakefield Corporation. Following partial demolition to make way for the Town Hall, the Tammy Hall became part of the constabulary depot for the local police force and fire brigade and today forms part of Wakefield Magistrates' Court.

In addition, the economy was sustained by agriculture, principally market gardening, supplying the more densely populated towns. From the agricultural

The truncated remains of the Tammy Hall of 1778. Converted into a worsted mill by the Marriott family, in the 1870s it became Wakefield's fire station, before becoming the magistrates' court for a time.

districts along the east coast, Wakefield received large quantities of corn and wool. By 1843, the corn trade in Wakefield was noted as employing

> about three hundred vessels of from fifty to ninety tons each. The corn-market, held on Friday, is second only to that of London, and it frequently happens that for many weeks in succession the quantity sold is greater than at Mark Lane. There are ranges of large corn-warehouses on the banks of the river. Malt, which was formerly brought from other districts, is now made at Wakefield to a very large extent. The wool-fairs are also on a large scale.

Of such importance was Wakefield's corn trade that the Corn Exchange and its method of sale were cited by Parliament in 1838 during the process to review and abolish the Corn Laws. By 1890 the city had a proliferation of malt houses, many built in the narrow yards running from the principal streets, or were vast complexes built along the banks of the River Calder, where between Wakefield Bridge south to Belle Isle no fewer than sixteen malt houses and or malt houses with kilns could be found, some being connected by both a low-level Kirkgate Station Corn Warehouse belonging to the Lancashire & Yorkshire Railway and also to water transport at Thornes Wharf. Here too

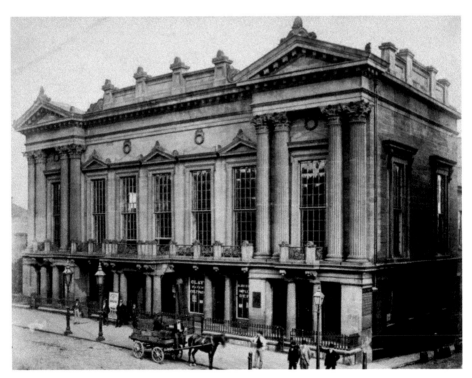

Wakefield's long-lost Corn Exchange. The wanton destruction of this fine building robbed Wakefield of one of its most important heritage buildings.

were three corn mills. For the sale of corn, a Corn Exchange was built on Westgate in 1820. It was replaced by a far larger building that stood opposite at the top of Westgate in 1837.

In addition, the town was nationally important for its Cattle Market, which had been established in 1765. Such was the scale of the business that by 1860 the Cattle Market was said to be the largest in the north of England and perhaps Europe. The Cattle Market closed in the 1960s, but its legacy lives on with the road name 'Fair Ground Road'. Cattle needed fattening up after being walked the long distances to market, and such was the scale of the industry at this time that any potential grazing lands surrounding the market were turned over for the purpose. Wakefield had been granted the right to hold market in the reign of King John. It met originally in the marketplace at the head of Westgate, which eventually became infilled with buildings. A market cross was erected in 1701. In the 1850s a new market was built off Westmorland Street.

At the end of the nineteenth century, Wakefield was served by excellent transport links by water, road and rail. Transport by water came to Wakefield under an Act of Parliament dated 4 May 1699 whereby the Aire and Calder Navigation was constructed, making the River Calder navigable, which opened to Wakefield from 1702 and boosted the town's economy greatly. Those backing the scheme were wealthy woollen merchants. The water transport links expanded throughout the eighteenth and early nineteenth centuries, linking Wakefield with other centres of production and the port of Grimsby. A second source of water

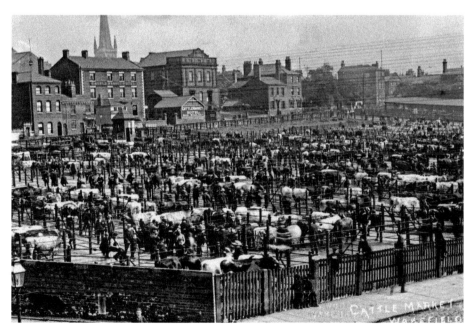

The Cattle Market, on Denby Dale Road and Fair Ground Road, was established in the mid-eighteenth century and was once one of the largest in Europe.

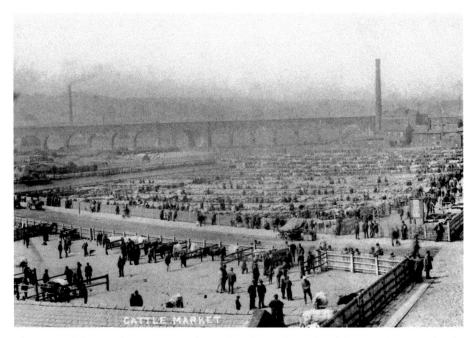

This view of the now long-gone Cattle Market shows the scale of the complex at its height in the years before the First World War.

transport, the Upper Calder Navigation, linked Wakefield to other business centres from 1758 when the Act was passed which authorised its construction. Later canals and navigations that linked Wakefield to wider markets included the Barnsley Canal, which was built from 1793 onwards. However, the tolls from the Aire and Calder Navigation by 1730 were so small that the company was taken over by lessees.

The Aire and Calder Navigation carried more than just woollen goods. In 1830, Smithson's tramway, the Lake Lock Railroad, transported coal from the mines at New Park to staiths on the navigation. This was the world's first public railway, decades before the Surrey Iron Railway, the Stockton & Darlington or Liverpool & Manchester Railway, or even Fenton's Railway, belonging to the Duke of Leeds. The company was headed by Unitarian cloth merchant Benjamin Heywood, who lies beneath Westgate Chapel. The Lake Lock Railway and Fenton's Railway transported 110,000 to 150,000 tons of coal to the staiths on the navigation every year. Coal mining became a boom industry in the town as the nineteenth century progressed. Such was the importance of coal mining to the commerce of the city that the National Coal Board eventually became Wakefield's largest employer, with Manor Colliery on Cross Lane and Park Hill Colliery at Eastmoor in operation until 1981 and 1983 respectively. Indeed, by the early nineteenth century it was estimated that a seagoing vessel of 100 tons burthen could reach Wakefield from the Humber, a journey said to take eight hours. All the coal mines

The boardroom of the Aire and Calder Navigation Company at Chantry Bridge. Amongst the shareholders of the concern we find Arthur Heywood, who invested £30,000, which originated primarily from his activities as a slave trader.

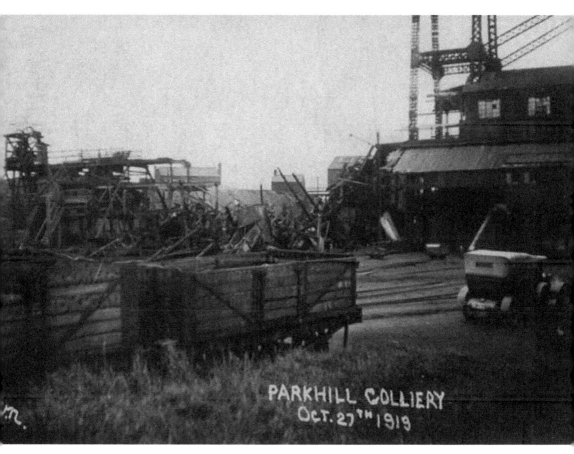

PARKHILL COLLIERY
OCT. 27TH 1919

Park Hill Colliery at Eastmoor was just one of several collieries around the city.

and bar one of the mills have closed in recent decades, being replaced by light industrial areas and service centres for international companies.

In the middle decades of the eighteenth century a second transport revolution took place with the establishment of turnpike trusts in the West Riding as a whole. The promoters of these toll roads promised an alternative system of transport than that offered by the canals and navigations. From 1741 Wakefield was linked to the then expanding turnpike network: linked to Halifax via the Wakefield and Weeland turnpike road, Wakefield and Halifax turnpike road and the Doncaster to Halifax Road, which also ran through Wakefield and linked the town to the Great North Road, parts of which became turnpike from 1745. The first entirely new route to come directly to Wakefield was in 1789, and was the Wakefield to Aberford road, and this replaced a section of the older road from Wakefield to York. The new road passed mostly across countryside where there had been no previous road. In 1825 the new Denby Dale road was authorised to be constructed by Act of Parliament, and extended ultimately to Holmfirth, Stalybridge and Manchester. To meet the new road on the Ings, Market Street was opened up from the top of Westgate,

The Great Black Bull Hotel on the corner of Market Street. Created in 1826 to link Westgate with the newly completed Denby Dale Road Turnpike and Westgate, it originated in the eighteenth century as a coaching inn to serve the nearby Cattle Market. Today it houses artists' studios.

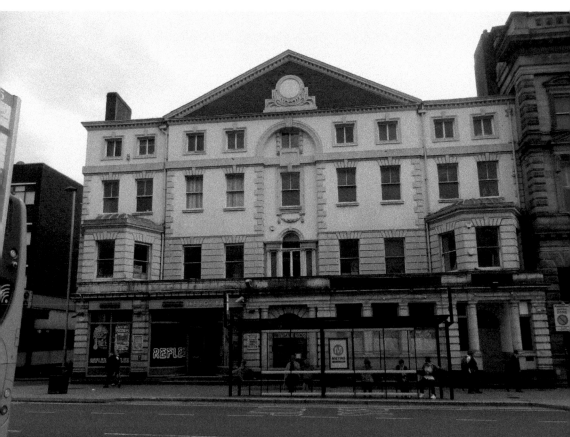

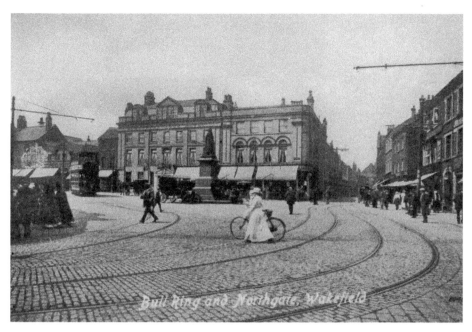

The Strafford Arms on the Bull Ring was one of Wakefield's premier coaching inns and latterly hotels. Its destruction in the 1960s robbed Wakefield of a key landmark.

and passed along the side of the Cattle Market. The road was disturnpiked in 1874. A third turnpike was built, planned to link Kirkgate to Westgate, bypassing the then town centre, work commencing in 1831. In 1863 the road was purchased by the Wakefield Local Board. This road today is Ings Road. In the more modern era, the building of the M1 and M62 motorways connected Wakefield to a system of fast, safe and more sophisticated roads. With the turnpikes, coaching inns flourished in Wakefield, notably the Strafford Arms and the Great Black Bull.

The improved roads allowed for quicker journey times and encouraged the expansion of stagecoaches, linking Wakefield with the wider world. Allied to the development of the stagecoach and improved roads was the introduction in second half of the nineteenth century of horse buses. The double-deck and single-deck horse-drawn bus and the hackney cab services provided quick and cheap transport in an era before the electric tram, motor bus and motor car. Such was the pressure on the roads of Wakefield from the motor car that many were widened and an inner-city bypass, Marsh Way, was constructed. In more recent years the city centre has been largely pedestrianised, along upper Kirkgate and Westgate, to increase footfall to the shopping precinct here and the Ridings Shopping Mall. The 1950s ushered in the then new and expanding network of motorways to Wakefield.

Although a number of tramway schemes had been proposed for Wakefield from the 1870s onward, the first to be constructed was promoted by a group

of local businessmen and authorised by the Wakefield & District Light Railway Order of 1901. On 25 April 1903 the Yorkshire Electric Tramways Construction Syndicate Ltd was formed to build the tramway. The West Riding Tramway Act of 1904 authorised the Wakefield & District Light Railway Company to construct additional Wakefield lines together with various extensions, which connected the Five Towns area with Wakefield and Leeds.

Above: A busy day at the top of Westgate in summer 1879. Horse cabs stand at the cab stand at the top of Westgate, while tradesmen with their horse and carts go about their daily business.

Left: A horse bus stands by the west door of the cathedral while a workman passes with his cart out on deliveries.

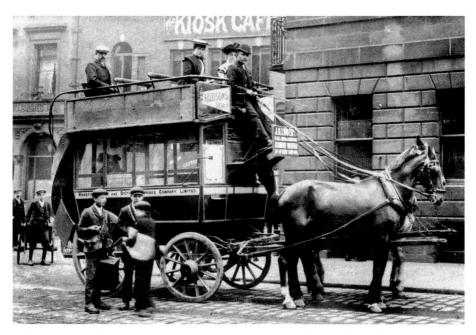

A horse bus stands at the top of Westgate outside the long-demolished old Corn Exchange.

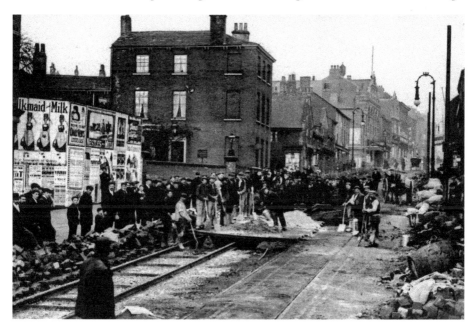

Laying tramlines along Westgate in the years before the First World War. To the centre left of the image we see the parsonage of Westgate Chapel, completed in 1803 for Revd Thomas Johnstone by the Unitarian architect and builder John Robson. Beyond we see the multi-gabled premises at the head of Scott's Yard. These late medieval buildings were swept away in the 1960s when everything new was good, and everything old was bad; sadly a mentality still very common in Wakefield where its heritage buildings are concerned.

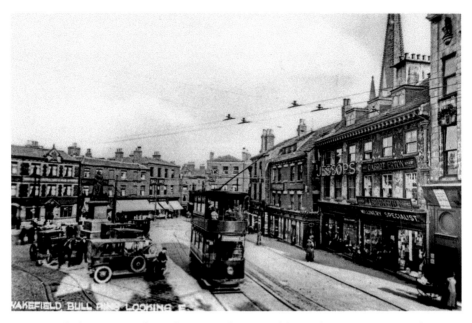

Trams jostle for space in the Bull Ring with cars and horse-drawn carriages in the years before the Second World War.

From 1840 Wakefield was linked to the then developing railway with the opening of Kirkgate station on 5 October 1840. In 1857, the line from Wakefield to Leeds was opened, and Westgate station was opened in 1867.

The population of Wakefield grew by just over 50 per cent between 1801 and 1850, and manifested itself with extensive and unrestricted building of small

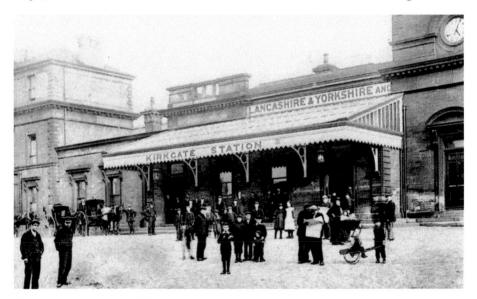

The entrance canopy to Kirkgate station, *c.* 1900.

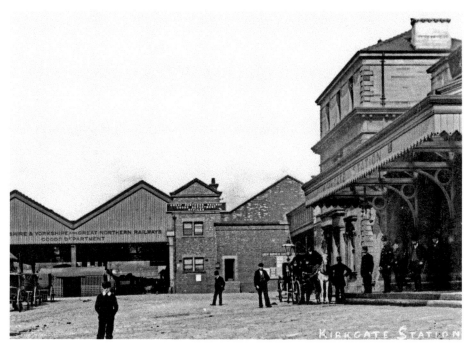

The goods shed at Kirkgate station was demolished in the first decade of the twenty-first century for car parking.

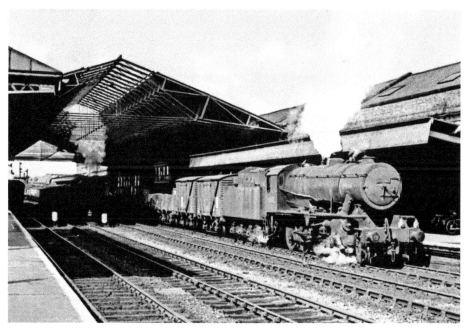

Kirkgate station, *c.* 1960, showing a filthy Riddles 2-8-0 goods engine on a typical freight train of the era. The locomotive was likely shedded at Normanton or Belle Vue, both now demolished.

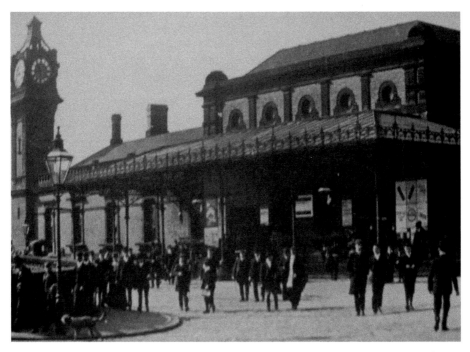

The second station on Westgate incorporated this fine Italianate-style edifice, demolished in the 1960s to make way for a 'horror nasty' piece of humdrum utilitarian architecture. The first Westgate station was the central block of a fine Georgian mansion belonging to John Milnes, designed by Robert Carr and completed in 1750. The 1960s station was swept away in favour of a more modernist design on Mulberry Way in recent years.

houses on every available piece of land, including along the edges of yards dating back to the medieval origins of the town. Down the side of the yards rows of small houses were built, leaving narrow passageways either side, 3 to 4 feet in width. The west side of Kirkgate was a typical example of this type of building, a wide main street with some fashionable houses fronting onto it with, at intervals, passageways leading to dark alleys running at right angles between the houses. Water was supplied from wells. A report sent to the House of Commons in 1848 noted that in the town's 168 lanes, yards and streets examined in 1847, ventilation of twenty-two were good, being open at both ends, thirty-one middling, open at one end, and 115 bad, being totally enclosed. In these 168 lanes there was a population of 13,074 living in 2,707 houses. Of these houses only eight yards and courts had good drainage, sixteen 'middling', and 144 bad – the street effectively acted as a gutter. Thus, over 70 per cent of the population of Wakefield in 1847 were living in badly ventilated, badly lit, badly built and badly drained houses. One of the worst areas of the town was around Nelson Street, where the inhabitants were mainly of Irish extraction, having migrated during the building of the railway and canals. The 1851 census reveals that the twenty-six dwellings in Nelson Street had a population of

233, an average of nine people per dwelling, whereas, on average, five people occupied each dwelling in the town. This means that Nelson Street and the surrounding area had a population 125 per cent higher than the overall average for the town. This average is, however, misleading, as a number of houses had less than average occupancy and some more: six houses were occupied by four or less, and others between six and sixteen. In general the houses in the town with the highest occupancy rates were those in which the householder or his wife's occupation was noted as being 'Lodging House Keeper'. Indeed, it was not until the 1871 Public Health Act that back-to-back houses were prohibited. However, whilst this regulation applied to the building of working-class houses, the houses of the middle and upper classes had been subject to regulations regarding sewage disposal, ventilation, paving and design as early as 1800 but not by statute.

Right: The overcrowded nature of the then town centre of Wakefield is clearly evident in this aerial shot of 1879.

Below: Briggs Café, Union Street. Shops, houses and retail outlets were packed together cheek by jowl in the overcrowded town centre.

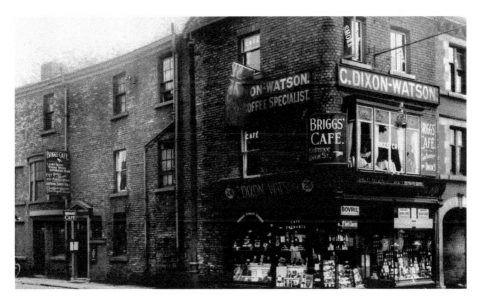

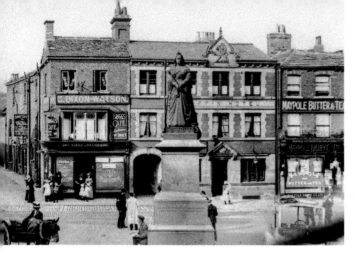

The Bull Ring, *c.* 1910. It was common for shopkeepers and publicans to live above their premises.

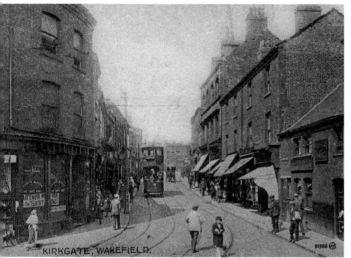

Left: The bottom of Kirkgate, *c.* 1910. The narrow and claustrophobic nature of the town centre streets is evident.

Below: Industry and housing were often side by side. Almshouse Lane Brass Foundry occupies the centre and left of the image. To the right we see terraced housing and the tower of Holy Trinity Church, George Street, and the premises of Eagle Brewery. Dirty and overcrowded, the area was demolished wholesale in the 1950s.

The 1871 Act also gave the Corporation the power to close houses unfit for human inhabitation, but does not appear to have been applied in Wakefield. Prior to the Act being passed, new residential areas of back-to-back housing were constructed throughout the town and neighbourhood. New streets were laid out and houses built between Northgate and Stanley Road; Saville Street and York Street, are examples. This area was gradually in-filled, the new working-class housing contrasting starkly with the early Victorian middle-class houses on College Grove Road and the development of large Victorian villas around Westfield. Other developments occurred off Westgate, New Scarborough and New Brighton being laid out at this time, as was Belle Vue and Primrose Hill.

In the years immediately after the First World War, new council housing schemes were constructed, the first being at Portobello in Belle Vue from 1924, to replace the cramped and often overcrowded inner-city housing stock. New council estates were built in Lupset (from 1921), Eastmoor and Darnley (from 1930), and at Flanshaw and Peacock (from 1936). Lupset estate was expanded in the 1960s with the building of houses at Snapethorpe. As well as provision for new working-class homes, between Dewsbury and Alverthorpe Road a new 'Garden City' housing scheme was developed for the more affluent members of the working class. Ribbon development also arrived in the 1920s and 1930s along Horbury Road and Thornes Road as the city expanded and established new suburbs. High-rise living came to Wakefield in the 1950s and 1960s; the tower

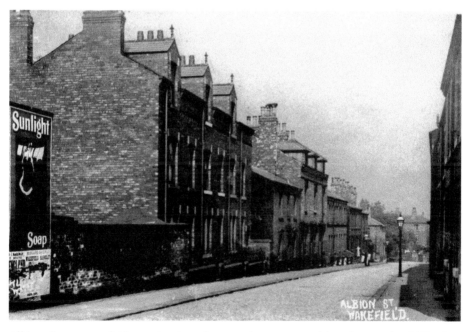

Albion Street was laid out in the 1820s as low-cost working-class and middle-class housing, which was preferable to living in the squalid housing in the yards and alleyways of the then town of Wakefield.

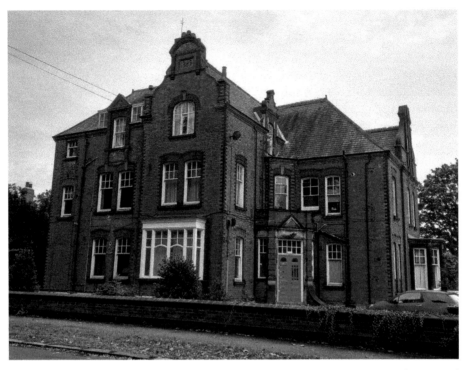

Blenheim Road and neighbouring streets were laid out in the 1880s. One of the largest and most imposing homes is No. 28 Blenheim Road. It was completed in 1889 by Wakefield industrialist William Thomas Marriott as a home for his daughter and her husband, Revd Andrew Chalmers. The house was designed by nationally important architect J. W. Connon. Connon, like Marriot and Chalmers, was a Unitarian. Chalmers was minister at Westgate Chapel. The house is under threat of demolition.

blocks dotted around Wakefield dominate the skyline. In more recent times new private housing schemes have been built both on outlying land around Wakefield or derelict industrial sites close to the Waterfront or by Westgate railway station. Mills and warehouses on the waterfront and former Methodist chapels have also been converted into private accommodation.

The responsibility for the government of Wakefield lay with the board of 161 commissioners who were nominated under the Improvement Act of 1771 and were responsible for the state of the streets, sewerage and drainage. However, by the 1840s there was dissatisfaction with the commissioners' application of their powers, and a committee was formed to apply for a charter of incorporation. Wakefield received its charter of incorporation in 1848, which was to consist of twenty-four elected councillors and eight aldermen. The first election took place on 13 May 1848, and George William Harrison, at some time both a Quaker and Methodist, became the first mayor. The charter allowed for the governing of the new borough (not to be confused with the medieval borough) to be undertaken by two bodies: the corporation

and the commissioners. The commissioners were responsible for the paving, street lighting, sewers and cleansing, whilst the corporation was responsible for the police and fire service. Dissatisfaction with the commissioners' inability to improve the conditions of the town led to a public meeting of the leading citizens to request that the Public Health Act of 1848 be applied to Wakefield. Today Wakefield is still administered under the terms of the original charter, but with universal suffrage.

The administrative centre of the County Council of the West Riding was established in Wakefield in 1889 through the Local Government Act 1888. This came to an end in 1974 when the West Yorkshire Metropolitan County Council was formed. County Hall was built to accommodate the County Council in the four years from 1894, being officially opened by the Marquess of Ripon on 22 February 1898. The original building was extended within a few years, with new wings being added between 1912 and 1915. The builder was George Crook of Wakefield. The council was discontinued in 1986, and the County Hall was acquired by the City of Wakefield Metropolitan District Council in December 1987 to continue the use of the building for local government purposes – as the council's main headquarters, supplemented by the nearby 'Wakefield One' on Burton Street.

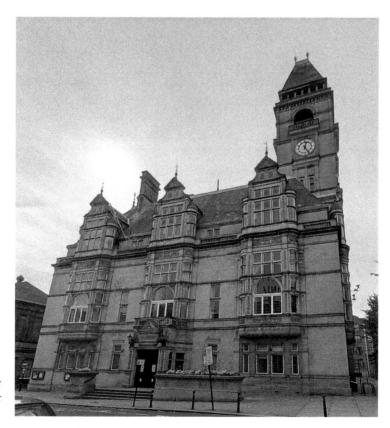

Wakefield's magnificent Town Hall still fulfils its designer's intentions over 100 years after completion.

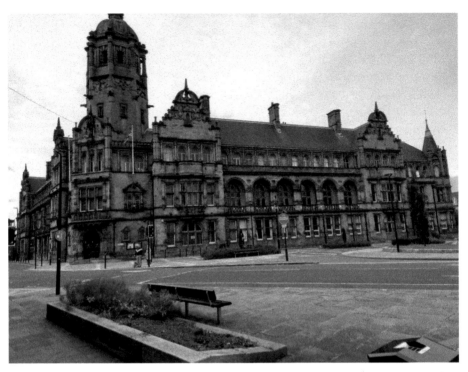

The former County Hall on Bond Street, built during the chairmanship of the West Riding Country Council of Sir Charles Milnes Gaskell, president of Westgate Unitarian Chapel.

At the end of the nineteenth century medical treatment was provided for the poor people of Wakefield by medical charities along with an increasing number of private doctors and medical men. Wakefield in the middle decades of the twentieth century could boast five hospitals, as well as the West Riding Lunatic Asylum, originating from the first half of the nineteenth century or earlier. Clayton Hospital moved from Wood Street to Northgate between 1876 and 1879 with the construction of new buildings. The infirmary of the New Union Workhouse on Park Lodge Lane (erected in 1851) was developed as Wakefield County Hospital, becoming part of the National Health Service in 1948. After 1968, it too catered mainly for elderly patients. All the workhouse buildings have now been demolished and the site is occupied by a housing estate.

Pinderfields General Hospital originated as part of the West Riding Pauper Lunatic Asylum (established 1818) through the efforts of Dr William Bevan Lewis in 1867 to provide separate accommodation for the recently diagnosed mentally ill. The hospital was expanded in 1899, with new buildings being opened on 8 March 1900 at a total cost of £69,000. However, outbreak of war in September 1939 meant the hospital was designated an emergency one to treat the war injured. Farmland next to the hospital was acquired and huts were built

to increase capacity. The mental patients were transferred to asylums across West Riding. Today a new Pinderfields General Hospital has replaced the former premises. Clayton Hospital, Pinderfields Hospital and the County Hospital in 1948 provided state-funded healthcare under the terms of the Beveridge report. Snapethorpe Isolation Hospital was opened in 1907 and closed in 1959. Maternity cover was provided from 1931 by Manygates Hospital, as well as private midwives.

Education in Wakefield at the turn of the nineteenth century was provided by a number of different bodies. Charitable schools comprised the Queen Elizabeth Grammar School and the Greencoat School. The established church provided parish schools such as the Bell School, Lancasterian School and Holy Trinity School. The Wesleyan Methodist Church ran the Methodist Day School. Private schools also existed, one such being the Heath Academy. Through the Education Act of 1870 the Board Schools on Ings Road, Westgate and Eastmoor Road were built (at some intervals). Attendance at school from the ages of four to twelve was compulsory by Act of Parliament in 1880. As the twentieth century progressed, empowered by the 1948 Education Act, more schools were built and others moved to new buildings, such as Thornes House School and the Cathedral School, moving from the old grammar school on Brooke Street to new premises on Thornes Road.

The derelict remains of the once magnificent Gothic edifice of Clayton Hospital. Largely financed by the Unitarian Gaskells and Milnes-Gaskells, the hospital was demolished during 2022 to be replaced by modernist classrooms for Queen Elizabeth Grammar School. The lack of concern for the plight of notable landmarks and their ongoing destruction in the city is a constant threat to the few remaining historic buildings in the cityscape. Retention of historic buildings is far more environmentally friendly as thousands of tons of CO_2 will be released to build new structures on the site. The destruction of Clayton Hospital and the fourteenth-century Westgate End House is symptomatic of lack of concern for heritage in the city by developers.

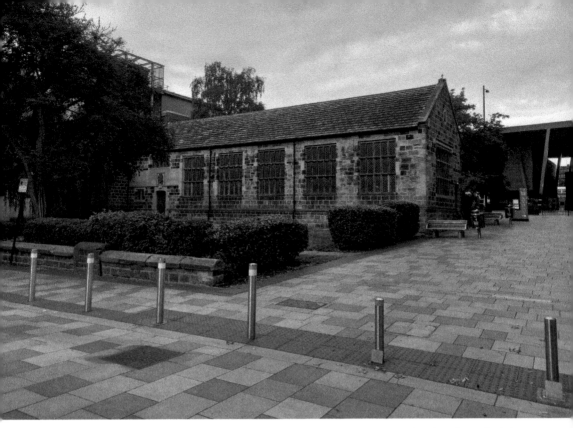

Above: The old Wakefield Grammar School on Brooke Street. Completed at the end of the sixteenth century, it is one of the oldest buildings remaining in the city.

Below: The imposing neo-Gothic buildings of Wakefield Grammar School on Northgate.

Since 1878 Wentworth House has been home to Wakefield Girls' High School. The house, completed in 1803, was largely paid for with proceeds derived from the slave trade.

The apparent lack of religious belief (or at least its practice) amongst the working class and urban poor was a constant Victorian concern. In the first half of the nineteenth century Wakefield and the surrounding area gained several new parishes, and in the town itself the parishes of Holy Trinity (20 October 1844), St Mary's Primrose Hill (3 September 1844), St Andrew on Peterson Road (3 September 1844), St Michael's (1869) were created. Wakefield had a strong sense of Nonconformist worship and by 1936 Wakefield as an area had over thirty Methodist chapels. The grandest of the Methodist chapels was West Parade Wesleyan Chapel, opened in 1803. Market Street's United Methodist Free Church of 1857, Grove Road's Methodist new Connexion Chapel of 1866 and Brunswick United Methodist Free Church of 1866 all added to the architecture of the cityscape. The Unitarian Chapel on Westgate (built in 1752) had members from the great and good of the local citizenry. Indeed, Westgate Chapel and its congregation played a leading part in the social, civic and economic development of Wakefield. In later decades the congregations at Zion Chapel and West Parade Chapel played a part in the town's economic and social development. In 1888 when the Diocese of Wakefield was formed, the parish church became Wakefield Cathedral, and the town became a city. William Walsham How was the first bishop.

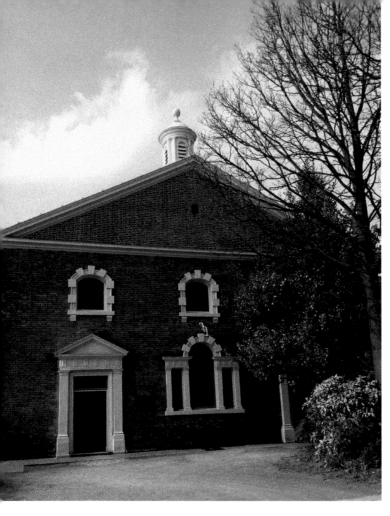

The Unitarian chapel on Westgate was opened on 1 November 1752. It incorporated the internal fittings and furnishings from its predecessor of 1697, which stood further down Westgate. Westgate Chapel was the first place of worship built in Wakefield after the Reformation of 1539, and marked its 360th anniversary of the founding of the congregation on 6 November 2022.

For entertainment, the people of Wakefield in 1880 had the choice of a plethora of public houses at which to drink, the temperance bar for those abstaining from alcohol, and for those interested in a cultured night out, this was provided for by the Theatre on Drury Lane, supplemented with the Empire Theatre on Kirkgate after the turn of the century. Many churches and chapels also provided their own evening activities, reading rooms and sports clubs. The coming of the cinema in the years immediately prior to the First World War brought a cheap mass market media and witnessed the building of numerous inner-city cinemas such as the Play House on Westgate or conversion of existing buildings into cinemas such as the Corn Exchange, the Empire Theatre, as well as the Theatre Royal and Opera House. A roller rink was also built on Ings Road offering a different form of recreational activity. In many ways a night out in Wakefield in 1900 and 2022 is remarkably similar, bar the convenience foods available in the modern era. However, in recent decades, all of Wakefield's older cinemas have closed, and many inner-city bars and clubs have closed down, along with many of the dance halls like the Embassy Ball Room off Market Street. Wakefield Trinity Rugby Football Club moved to its current home in Belle Vue in 1879.

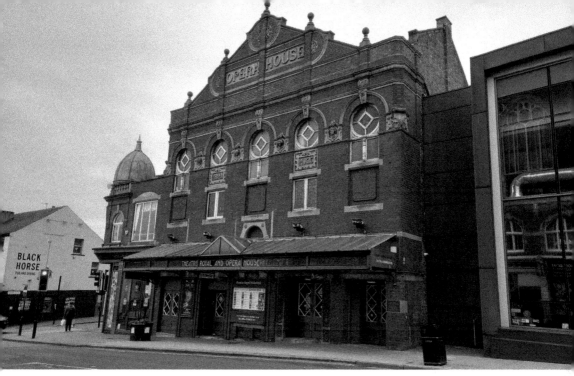

Above: Wakefield Theatre Royal is the second theatre on the same site. Wakefield's Victorian gem was one of two theatres in the city designed by internationally known Frank Matcham. Sadly, the Empire on Kirkgate, completed in 1909, was demolished in 1962, in an era when everything old had to be swept away by city planners.

Below: Completed in 1913, the Picture House cinema is the sole remaining city centre cinema. The Empire in Kirkgate, the Odeon also in Kirkgate, the Grand Electric on Westgate in the Corn Exchange, the Hippodrome on Teal Street and the Tivoli on Grove Road have all been demolished. In 1921 a Conacher organ was installed and in 1929 the Picture House was wired for sound. The cinema closed in the 1970s and became Roof Top Gardens nightclub. The building's ramshackle appearance detracts from Upper Westgate Conservation Area. The once grand marble façade is covered in peeling paint.

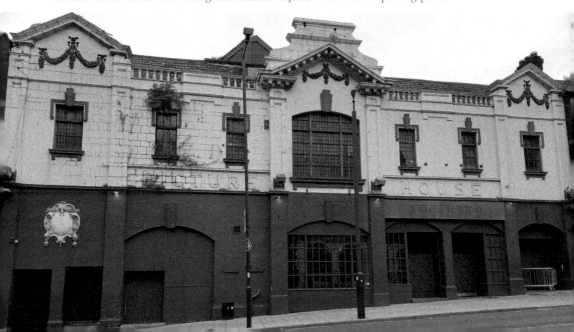

Wakefield's commercial base, as well as its townscape, has fundamentally altered in the last thirty years and is set to change again. The town is bereft of its mills and pit heads, and its manufacturing industry. Industry does remain in the many industrial estates. In the place of mills, factories and open fields are new housing estates to cater for those working elsewhere like Leeds or Bradford, or empty office park developments. The city also provides jobs in the bar and leisure industry, as well as the IT or service industry. Recent development has seen the new shopping mall of Trinity Walk laid out, a new urban centre at Merchant Gate betwixt Westgate and Balne Lane, as well the impressive £35 million The Hepworth Wakefield, named in honour of local sculptor Barbara Hepworth, which opened in May 2011. The 2022 Wakefield Masterplan aims to regenerate large swathes of the city centre and to bring historic landmark buildings back into use.

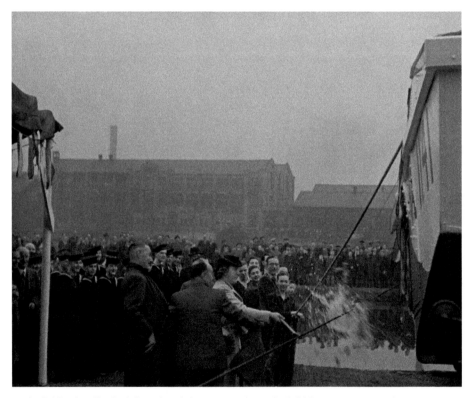

Wakefield is landlocked, but this did not prevent Wakefield businessman and entrepreneur Charles Henry Drake – the author's great-grandfather – as co-partner in Wakefield firm Drake & Warters, obtaining the contract to build seventy-two landing craft during the Second World War. The first was launched on 13 October 1943 at Earnshaws timber yard on Doncaster Road (today Howarth Timber).

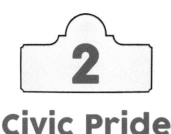

Civic Pride

The thirty-year period from 1785 saw Wakefield experience a huge expansion of business, primarily in the cloth trade. The receipts of the Leeds to Halifax turnpike rose from £852 to £3,500 between 1785 and 1800, and the receipts for the Aire and Calder Navigation tolls trebled from £40,033 a year in 1782 to £150,268 in 1802. This rapid increase was brought about by the growth of internal and external trade routes, primarily in cloth. The town's economy was underpinned by cloth finishing and dyeing. The sale and finishing of cloth was dominated by Westgate Chapel men like Richard, John and Pemberton Milnes or John and Jeremiah Naylor; the Milnes family, who came to Wakefield from Chesterfield in the late seventeenth century, controlled over 50 per cent of the cloth trade of the West Riding.

This boom time was not to last, but by 1800, fuelled by this peak in commerce, Wakefield gained many new civic institutions. The leading townsfolk had established a number of educational establishments and both voluntary and philanthropic organisations, including a library founded in 1786 and the Dispensary founded in 1787. In Crown Court, the building displaying 'Town Hall' on its façade has a fascinating story. It had originally been built as the New Assembly Rooms. The George and Crown Yard, leading from Crown Court, was named after an inn that once stood at the Silver Street end, and was an early home of the Freemasons. Like many hundreds of buildings in Wakefield, the New Assembly Rooms building's purpose changed over its 200-year history, and is still doing so. As often happens, a building's use often changes from the intentions of the original builders.

The building was erected in 1798 as the New Assembly Rooms, the original assembly rooms being a part of the White Hart Inn which stood on Kirkgate. It was variously known as the New Assembly Rooms or the Music Hall. Wakefield's first newspaper, the *Wakefield Star*, which was founded in 1803, was published from here. As a dance hall and music venue the New Assembly Rooms seems to have closed in 1821 or 1822, perhaps due to the building of the Music Saloon nearby on the recently laid-out Wood Street. After spending time as a Methodist chapel, in June 1858 the building was gutted by fire. It

The New Assembly Rooms in Crown Court, opened in 1798. From 1804 the premises housed the *Wakefield Star* newspaper owned by Westgate Chapel families and edited by Revd Dr Martin Joseph Naylor, a priest at the parish church. When the paper failed in 1822, the premises became a Methodist chapel, then the Town Hall for Wakefield from 1848 and later still an organ building factory. Today it is a residential development.

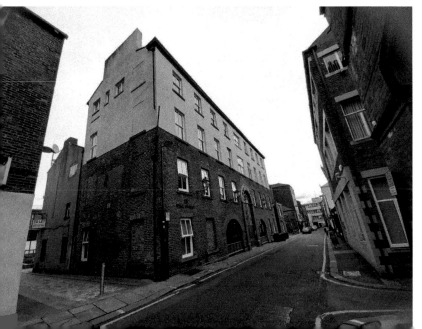

The vast wool warehouse of Joseph Jackson on King Street, where Titus Salt was apprenticed, was one of dozens of such buildings in the town. It is the sole remaining example.

St John's Square was laid out in the 1780s as a 'new town' development. It marked the peak in Wakefield's material prosperity.

St John's North was laid out by John Lee as part of his new town development.

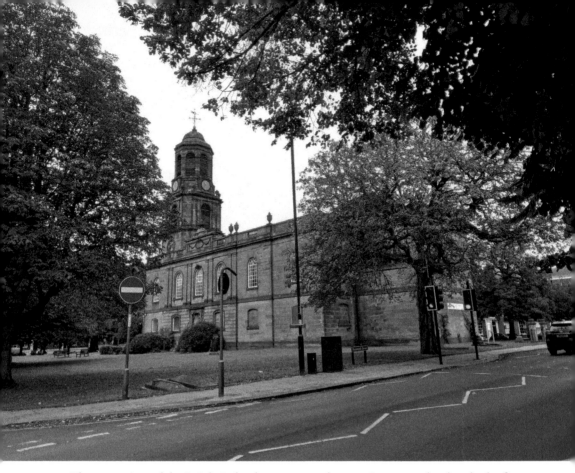

The centrepiece of the St John's development was the stunning namesake church, the first Anglican church built in Wakefield as a replacement for the long-closed St John's Church on Northgate.

was this burnt-out shell that Wakefield's councillors decided to lease as a Town Hall in 1861, paying the owner, John Bayldon, a substantial sum to rebuild it to the Corporation's needs. The site between the Court House and the Music Saloon on Wood Street (formerly the City Museum, now premises for Wakefield College) was purchased by Wakefield Corporation in 1854, but it was not until 1877 that the building work commenced on a new town hall. The building was designed by T. W. Colcutt, a London architect, in a French Renaissance style. The foundation stone was laid by the mayor, Alderman W. H. Gill, solicitor, in October 1877, and the building was opened in October 1880 by the Mayor W. H. Lee, whose names are commemorated by Gill Street and Lee Street, which adjoin the building.

Further civic developments witnessed the foundation of the county court in the newly laid-out Wood Street. Land was purchased in 1806, and the Court House was built for the West Riding magistrates to a design provided by Charles Watson, an architect based in Doncaster who was also architect of the St John's South Parade developments and West Parade Wesleyan Chapel. A delay in completion

was reputed to have been because there were problems obtaining large enough blocks of stone for the pillars, but Quarter Sessions were held there from 1810. The building was extended in 1849–50 and again in the 1880s. County Courts ceased to be held there in 1992, and at present the building remains empty.

In 1820 subscriptions were raised to build Public Rooms at the town centre end of the street, with a grand Music Saloon on the upper floor. Shares were offered at £25. Prominent among its promoters was the Vicar of Wakefield, Samuel Sharp. It seems that money was slow to come in. The building work took many months and the saloon itself did not open until 22 December 1823. In 1855 the Mechanics' Institute purchased the building and in 1935 it was sold to Wakefield Corporation, becoming the town's museum in 1955. The museum moved in 2012 to the new Wakefield One building.

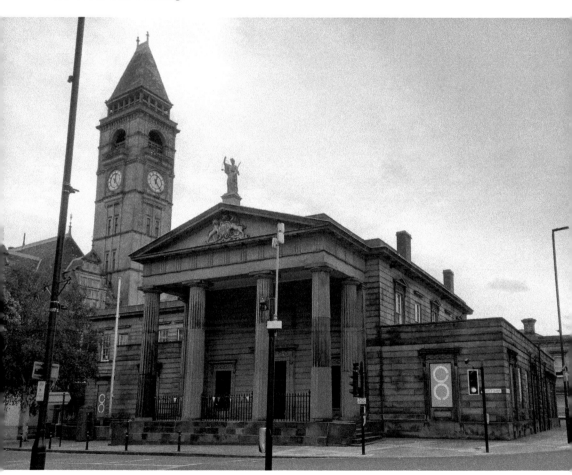

Completed in 1803, Wakefield Court House was one of the first, if not *the* first, neo-Greek building in the British Isles. Built to the designs of Charles Watson of Doncaster, who also designed St John's Church and Square, the houses on South Parade and West Parade Methodist Chapel, the building has been empty since the early 1990s.

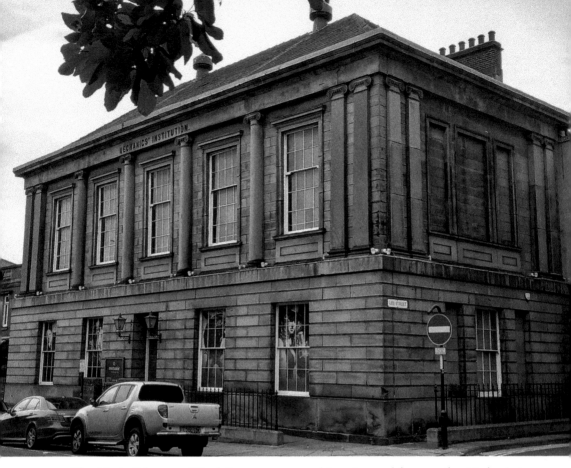

The Music Saloon on Wood Street was opened in 1823 and became the Mechanics' Institute and later City Museum, before becoming premises for the City College.

As well as places for dancing, Wakefield also boasted one of the earliest theatres in the West Riding. James Banks, in 1776, built Wakefield's first purpose-built theatre, the Theatre Royal on Westgate. Mr Banks, who was a wealthy wool merchant, built and resided in York House, which stands on Drury Lane behind the theatre, in the 1760s. His wife, Mary Banks (née Boldero), brought him a large dowry drawn from her father's slave plantations. For a while, plays and comic operas had been performed in the saloon of John Milnes Jr's grand Westgate home by theatre impresario Tate Wilkinson, who went on to manage Banks' theatre. Many famous actors starred there, including Mrs Siddons and Edmund Kean. The old theatre was condemned as a building in 1892 and Benjamin Sherwood, the owner at that time, had it demolished. A new theatre was built in 1894, to the design of the well-known theatre architect Frank Matcham, and renamed the Royal Opera House.

Simultaneous to the economic boom Wakefield experienced in the years before 1830, which witnessed the building of new civic institutions, wealthy residents transformed the streetscape. A number of the mansions of the 'merchant princes' remain, the oldest being completed in 1763 by master dyer

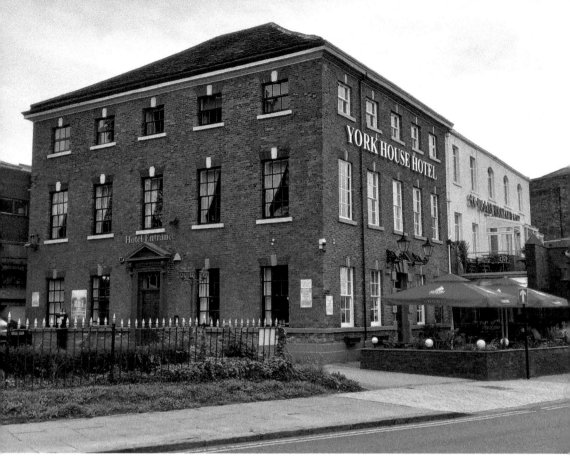

Bank House on Drury Lane was completed in 1776, largely thanks to money derived from slavery.

Robert Lumb, which stands on Westgate, as do the neighbouring Langton House completed by the Holdsworth family, Vincent House, onetime home of the Marriott family, and Pemberton House, home to Pemberton Milnes and his daughter, the Dowager Duchess of Galway. On Northgate stands Egremont House, the last remaining Georgian property on the street. As well as large 'statement houses' like Wentworth House, built by John Pemberton Heywood, the son of a prominent slave trader, the late eighteenth century witnessed the development at St John's, being promoted by John Lee, a Wakefield solicitor. The scheme was completed soon after 1800, with a uniform frontage design, but irregular backs. Some were built as shells – just walls, roofs and floors; interior dividing walls were added later. The process of urban development in Georgian Wakefield produced a landscape dominated by bricks and mortar. However, an aversion from this landscape was provided for the middle and upper classes with the creation of green spaces in new prestigious housing developments. This growing appreciation of how greenery could soften the hard edges of the urban landscape had stimulated the laying out of fashionable squares, such as St John's and South Parade.

Pemberton House, completed *c.* 1760 by Pemberton Milnes JP. Milnes was chairman of nearby Westgate Chapel, and was the most influential of the dissenting Whigs in the north of England. He was a close personal friend to his political ally Charles Watson Wentworth, 2nd Marquis of Rockingham, who resided at Wentworth Woodhouse. Milnes would build Bawtry Hall near Doncaster as his country seat in the 1770s. He died in 1795 and is buried beneath Westgate Chapel.

These squares were semi-public places, envisaged as open piazzas on the classical model, paved meeting places with a single statue or fountain providing a visual reference for the surrounding development. The formal avenues and manicured parterres mirrored the gardens of the large country house. In this way the classic English landscape garden was transported in microcosm into the heart of many Georgian towns. These squares were planted with natural shrubs and deciduous trees, especially elms, the upkeep of which was paid for by subscription or by being levied on the residents of the square. The house at the eastern end and seven other houses were erected by building society the Union Society, led by John Puckrin, a local builder. Like St John's Square, they were all constructed with a uniform design for the frontage by John Thompson, an eminent architect. As Wakefield grew rich during the Victorian era, as well as public spaces the town displayed its wealth with grand and opulent business premises. Standing in Westgate are the former banking premises of the Wakefield and Barnsley Union Bank, which was designed by H. F. Lockwood in 1877–78. At the top of Westgate stood one of Wakefield's grandest and most important buildings, the Wakefield Corn Exchange and public buildings. Designed by W. L. Moffat of Doncaster, it was opened in 1838 and enlarged in 1864. The building was demolished in 1962 after a small fire damaged parts of the building. This robbed Wakefield of one of its finest buildings. Another grand building, but with an uncertain future, is the former Wood Street police station, which was built in 1908 by Wakefield firm George Crook & Sons.

Today, Wakefield One is the most recent addition to the city's civic architecture.

Abolition of the Slave Trade

Wakefield was famous for two things in the eighteenth century: the woollen trade and slavery. The legacy of the slave trade and slavery in Wakefield is contested history. It is undeniable that the city benefited hugely from slavery thanks to the Charnock, Peterson, and Briscoe families and from the slave trade thanks to Arthur Heywood and the Ingram family. The economics of Georgian England were such that very few avenues in life were more than three steps away from slavery. The economy was largely based on slavery: slave plantations generated huge wealth, and the trade in people to work on the plantations made merchants spectacularly wealthy. Indeed, it has been reckoned that between 1761 and 1808, British traders moved 1,428,000 African people across the Atlantic and pocketed £60 million – perhaps £8 billion in today's money – from the resulting sale of their fellow human beings. Wakefield men were key players in the slave trade. Arthur Heywood and his brother funded 134 slave voyages and transported 43,388 slaves. The grim tally – a conservative estimate – is 265,184 men, women and children dragged from their homes by the extended family of Arthur and Benjamin Heywood. Over a quarter of a million people.

The truth is, of the roughly 1.4 million men, women and children transported by the slave trade, 25 per cent of all slaves transported between 1700 and 1807 were transported into slavery by Arthur Heywood and his extended family. This crime has been ignored until now and needs to be brought into the light, explored and discussed.

Heywood was not unique, far from it, even in Wakefield. Francis Ingram and his family transported 41,412 people and Ellis Hodgson 55,010 – the latter not being a Wakefield resident when he did so. Three men who lived in Wakefield and district transported between them 139,810 men, women and children, of which over 15,000 died on the voyages. Wakefield has a dark past and played a significant part in the slave trade.

Far outstripping the importance of the slave trade and slave-produced merchandise in terms of raw economics was trade with the American colonies, which when coupled with growing internal markets to cater for a burgeoning

middle class – which emerged on the back of the trade with America – allowed Great Britain to dominate world trade, finance the Napoleonic Wars, take over India in a war of rape and conquest, as well as to fund the beginnings of the Industrial Revolution at home. Slavery benefited England in various complimentary economic spheres.

As well as making spectacular profits from dealing in human beings, and supplying the ever-expanding home market with chocolate, tobacco, cotton, sugar, rum and other goods, merchants made huge profits exporting goods with the North American colonies. The North American colonies grew rich on the back of supplying goods and services to the slave plantations in the West Indies: a new country became rich on the value-chains of slavery. The burgeoning American middle class had emerged as a political and economic force on the trade of goods and services to slave plantations. They desired high-status European goods to grace their homes as a sign of social ranking: fine china from Wedgwood, English woollen goods and other textiles.

The self-same ships and merchants who moved slaves, sugar, tobacco, rum and cotton also took to the American colonies' woollen textiles on a level far higher than any other manufactured products. English merchants based in the American colonies, like Thomas Charnock of Wakefield, the Diggles of Manchester and Heywoods of Liverpool became important providers of maritime services in the form of shipping and merchandising. The northern mainland colonies' economies evolved in such a way that the residents' purchases of European products were financed by the sale of services, timber and foodstuffs to the slave plantation. Wakefield at the start of the eighteenth century was the regional centre of the wool trade in north of England.

Burney Tops House, completed in the 1760s by the slave-owning Charnock family in Wakefield.

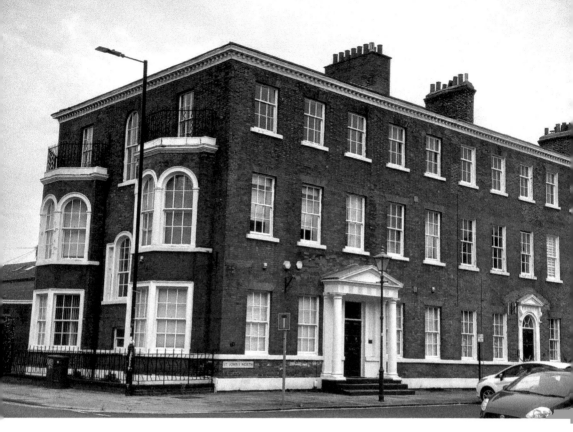

Above: The vicarage of St John's Church was home to Revd Munkhouse, whose dowry from his wife was shares in slaves and plantations from his father-in-law Arthur Savage, a notable slave owner. Revd Munkhouse passed the slaves and plantations to his daughters, who received a large lump sum in compensation when slavery was finally abolished.

Right: The Westgate banking premises of Ingram, Kennet and Ingram. The firm was bankrolled by the Ingram family's slave trading.

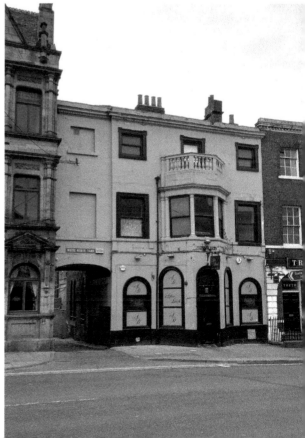

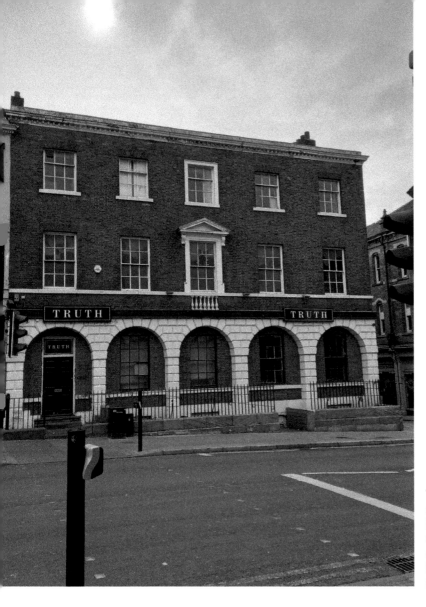

The Westgate mansion of Francis Ingram, a man who shipped over 40,000 human beings into slavery for profit.

The wealth of Wakefield in the eighteenth century, like that of the West Riding, was derived from the wool trade and its merchant community. This wealth was in part earned from slavery. American and Indian cotton came into Wakefield for finishing and export; broadcloth was made in Wakefield and sold to rich plantations owners; and low-grade cloth was shipped out to be worn by the slaves themselves. Indeed, we note that the Atkinsons of Huddersfield were shipping broadcloth to American slave plantations well into the 1850s until the American Civil War interrupted the profitable trade. The Milnes, Naylor, Banks, Charnock and Maude families built lavish mansions in the town, of which just a few remain, and also had black servants. Two slaves lived in Wakefield: 'merchant prince' Thomas Charnock, of the Grove, had his slave Richard Brown, a sixteen year old, baptised here in Wakefield in 1763. He

had been brought from North or South Carolina to work as a servant. Army officer Colonel Robert Prescot, who lived in a mansion on Westgate, organised the baptism of his slave John Vernon in 1764. John, the baptismal register of the now Wakefield Cathedral reports, was a slave from Antigua aged about twenty-two and it seems was named after prolific slave owner and trader John Vernon. No doubt both made much of the wealth and privilege that allowed them to own other human beings.

These families' dominance of the cloth trade prompted the expansion of the town, from 4,000 inhabitants in 1723 to 16,000 by 1801, to work in the various textile factories in the region. The woollen trade was reliant on slave goods for its existence: dyes like log wood, Nicaragua wood and cochineal were made by slaves. The Brisco family, who lived in Westgate, were merchants who imported slave-produced sugar, logwood dye, rum and molasses to Wakefield from their slave plantations in the West Indies. Richard Fennell and his son – father of the famous Louisa Fennell – made their fortune importing slave-produced goods to Wakefield and further afield. William White, a wine and spirits dealer, made handsome profits importing rum from slave plantations. Henry Peterson owned tobacco plantations, again managed by slaves. Records of the plantation and his purchase of slaves are preserved in the John Goodchild Collection. The sale of human beings to work these plantations, to make the goods to ship back to England, was where huge profits could be made for those with the finance to buy ships, fit them out and gamble on the ship completing its voyage. It was literally a simple case of supply and demand. The plantations needed slaves; the traffickers employed whatever means they could to supply slaves. Slave trading financed banking across the county; it was the acceptable face of capitalism.

It is undeniable that the town of Wakefield's late eighteenth-century prosperity rested on the profits of the transatlantic slave trade. Yorkshire has a hidden past that requires greater exposure than this book allows for. This book is, I hope, a springboard to understand the dimensions of the crime committed against African people by people from Yorkshire, without which contrition and gesture are meaningless. Slavery is utterly absent from museums across the county. We can no longer hide the fact that Yorkshire played a pivotal part in the slave trade. Yorkshire men and women committed a great crime in the name of profit. Liverpool has begun the process of restitution for its links to slavery, yet Yorkshire and indeed towns and cities like Halifax, Wakefield and Leeds have made no attempt to acknowledge the slave trade.

Yet not everyone was happy with slavery: a group of men and women centred at Westgate Chapel, Wakefield, said 'enough is enough'. Starting in 1759 a group of religious dissenters known as Unitarians began a campaign to end slavery. In Yorkshire, it was David Hartley, MP for Hull, who was a friend of the Milnes family of Wakefield and a supporter of Marquis Rockingham, that brought slavery into the political sphere, long before the

more famous William Wilberforce. A friend of Benjamin Franklin, he wrote in November 1775 that slavery was 'contrary to the laws of God and man' and a matter of months later, Hartley brought the matter of slavery to the House of Commons, saying that 'the Slave Trade was contrary to the laws of God and the rights of men'. He dramatically laid shackles on the table of the House during the debate to emphasise the point. In Wakefield, the Revd William Turner, minister at Westgate Chapel, declared in December 1776 that people had no power

> to assume the right to invade, and make property of their fellow creatures, and use them for their own advantage, pleasure of caprice, though it were to their bitter suffering and cruel oppression, both in body, mind and outward estate... whoever shall persist in the commission of unrighteousness, oppression and cruelty to their brethren, and, at the same time, attempt by fastings, however solemn, to bribe the righteous ruler of the world to connive at the wickedness, will only bring down on themselves his heavier vengeance for the aggravated insult.

About the rights of man Turner thundered:

> I trust my brethren, that none of us is chargeable with any flagrant acts of injustice and oppression, violence or cruelty against any if our inferiors; that we have no bands of wickedness to loose; no heavy burdens imposed by us on our brethren, to undo; that we have none oppressed or enslaved to set free, not any unreasonable or burdensome yoke to break; yet, let us strictly examine ourselves upon this head; and if we find, that in any respect we have approached the borders of oppression against any of our brethren, let the solemnities of this day engage us, without delay, to rectify and redress it, as far as we can, and in all our future conduct, to adhere closely to that golden rule.

Turner preached that power to govern was to be given by common consent, for the common good and not for the particular interests of a narrow group, noting men had been 'blinded by ambition and avarice, hardened against the feelings of humanity, and having perverted or lost all principal fear of God and righteousness to man'. Here was an attack against the government, the ruling classes and slavery. Slavery was 'front and centre' of Yorkshire politics and was increasingly making headway across the country. The 'Zong massacre' of 1781 helped focus public opinion: the mass killing of more than 130 enslaved Africans by the crew of the British slave ship *Zong* on and in the days following 29 November 1781. The trial in 1783 was heard by Lord Justice Mansfield with the rough-spoken Yorkshireman John Lee. The London Yearly Meeting of the Society of Friends decided shortly after to begin campaigning against

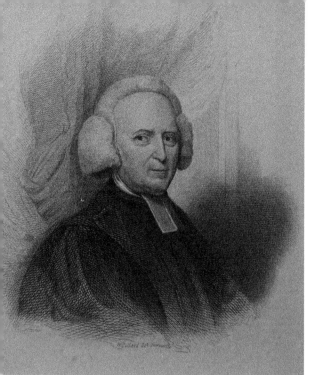
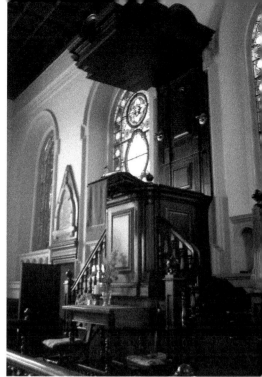

Above left: Revd William Turner, minister at Westgate Chapel from 1761 to 1792, whose fiery anti-slavery sermon, delivered on Friday 13 December 1776, sparked a nationwide campaign to abolish the slave trade.

Above right: The pulpit at Westgate Chapel from which Revd Turner thundered his anti-slavery polemic in 1776, where his successor, Revd Thomas Johnstone, damned slave traders in 1792 and 1801.

slavery, and a petition signed by 273 Quakers was submitted to Parliament in July 1783. A positive to come out of the great crime that the Zong massacre surely was, was that abolition as a movement was now moving forward like never before.

Thanks to Granville Sharp, David Harley, John Cartwright, Thomas Day and Josiah Wedgwood, abolition was now part of public and political conversation and a solid plan had been formulated on how best to bring an end to slavery. In late 1787 the Society for the Abolition of the Slave Trade, with Wilberforce at the helm, began a national campaign to raise petitions against the slave trade. Unitarians backed the Society in spite of being ostracised because of their faith and faced with open opposition from Granville Sharp for their religious beliefs. Relevant to Yorkshire, we note that the Manchester Society held a general meeting on 27 December 1787 whereby they sent a petition to agitate for the abolition of the slave trade to every mayor and magistrate in the country. From this came a flood of support in Yorkshire. Pemberton Milnes, as the leading Whig magistrate of the county, backed the call for raising committees in January 1788. Acting on the call from Manchester, a meeting was held at the Moot Hall

on Westgate, Wakefield, chaired by Thomas Lang, a leading Unitarian. The petition read:

Wakefield, 28th February 1788.

The petition of the Inhabitants of Wakefield and its Neighbourhood, in the West-Riding of the County of York,
Humbly Sheweth,

That your petitions, excited by the example of so many of their fellow subjects, have taken into their serious consideration the nature and effects of the trade carried on upon the coasts of Africa for the purchasing of Negro slaves, and cannot help regarding it with Abhorrence's, as contrary to every amiable sentiment of humanity, as violating the plainest principles of equity, and the rights of human nature, as irreconcilable to the spirit and precepts of the Christian religion. We are shocked at the destructions, defilations and miseries brought on the wretched natives by the wars and ravages which this detestable commerce is said to occasion.

We lament the miseries and oppressions which they suffer who are reduced to bondage in the British Colonies. We therefore earnestly request this honourable House to take these subjects into more mature consideration, and adopt such measures as shall appear most effectual for the relief of those already in captivity, and eventually to put a total end to a traffic which hath been too long a disgrace to our country and our religion. And your petitions will very pray &c.

Lang and the petition were seemingly calling for improved living conditions for slaves, an end to the slave trade and, reading between the lines, an end to slavery. One can hear the influence of Revd Turner in the words of the petition. William Wilberforce, on the strength of national feeling, presented a bill to Parliament to abolish the slave trade, which was, alas, rejected. Undeterred, Wilberforce, who was known to the Milnes family and had spent time at Thornes House, redoubled his efforts. When in 1792 the call was made for a second mass petition, no petition came from Wakefield. Westgate Chapel's youthful assistant minister, Revd Johnstone, preached in February 1792 that 'arising from equality of nature, the practice that has long prevailed among us, of extending our commerce to the human species, men who have never done us the smallest imaginable injury, must be utterly condemned'.

On the strength of the new petitions, Wilberforce went back to the House of Commons to vote on abolition. Wilberforce's next motion was held on 2 April 1792. His motion was accompanied by Wilberforce giving a remarkable three-hour-long speech and he gained William Pitt's support. The motion was granted a hearing by 234 votes to 87. However, Henry Dundas's proposed amendment for gradual abolition rather than immediate abolition was approved, with the date of 1 January 1796 given as the end of the slave trade. The motion was blocked in the House of Lords.

Revd Thomas Johnstone was appointed assistant minister at Westgate Chapel in 1792, and became minister from 1794 after the death of Revd William Turner. Johnstone remained in post until forced to resign by the chairman of the congregation, John Clarkson, in 1833. Johnstone, a political radical, was gaoled in 1793 and was the 'power behind the throne', along with others in his congregation, of the election campaign of Daniel Gaskell – also a Unitarian – to become Wakefield's first MP in 1832. He died in 1856 aged eighty-six and lies beneath Westgate Chapel.

The third person to speak in defence of the bill was Unitarian Benjamin Vaughan, 'who declaring that, despite being the eldest son of a plantation owner, and had control of a large plantation, he himself had never, and never would, own a slave', declaring 'I would sacrifice anything to a prudent termination of both evils, for all persons must with that neither had commenced' when referring to slavery and the slave trade. Wilberforce moved further consideration for the abolition of the slave trade on 26 February 1793. The motion was defeated by 61 votes to 53. Yet undeterred on 14 May 1793, Wilberforce got leave to present a bill to limit temporarily, as a wartime measure, the importation of slaves into British colonies. The bill failed, but Wilberforce remarkably did succeed in a vote to suspend supply of slaves to foreign colonies in British ships, passed on 7 February 1794, but again this was blocked by the House of Lords. Voting in favour of the bill in the Commons were Dick Milnes and Benjamin Vaughan. With dogged determination, Wilberforce presented another bill on 18 February 1796, and despite recent disturbances in the West Indies, he won the day by 26 votes for his motion to abolish the trade on 1 March 1797. Despite initial optimism, on the bill's second reading in the House it failed 74 votes to 70 on 15 March. A new motion was presented on 15 May 1797 and was lost by 82 votes to 74 on first reading. Undeterred, Wilberforce again presented an abolition motion on 3 April 1798; unsurprisingly it was defeated by 87 votes to 83. Less than a year later

the motion presented on 1 March 1799 was defeated by 84 votes to 54. Without support from the Whigs, who Wilberforce had done his best to alienate, the bill to abolish the slave trade would not pass due to insufficient support from both sides of the House. Yet despite Wilberforce's best efforts, slavery and the slave trade were never far from the lips of the radical Unitarian clergy. Revd Johnstone proclaimed from the pulpit of Westgate Chapel in February 1801 that:

> There is one other body of men to whom I should peculiarly wish the question to be asked: Are there not with you, even with you, sins against the Lord your God? These are the hardened and the brutal traffickers in human flesh, the slave merchants, who, devoured with the thirst of gain, can tear from their native homes, from all the endearments of life, from all that intercourse, which love, which friendship, or the warm emotions of a parent's heart, can render sweet and attractive, thousands of their fellow-creatures, and doom them, for life, to slavery's galling labour. This is indeed, a crying sin against us; and while permitted to exist in so wanton a violation of humanity, as not to have even the plea of policy or profit in its favour, it must draw down upon us the divine wrath. While this horrid stain remains upon our national character, never shall we be at a loss to account for any combination of misfortunes which may rise against us.

No further motions on the slave trade were presented until 30 May 1804 when Wilberforce's motion on its first reading was passed by the Commons by 124 votes to 49. The motion passed its second reading on 27 June, but the Lords adjourned it on 2 July. A year later, Wilberforce's motion was defeated at its second reading on 8 February 1805, by 77 votes to 70.

With the death of Willian Pitt, on 21 January 1806 the King reluctantly called a new government, termed 'the Ministry of all the Talents'. Charles James Fox, the Whig leader, was now back in office as Foreign Secretary. Pitt's first cousin Lord William Grenville was Prime Minister. The Whigs were on the rise. Fox's goals were simple: 1. to abolish the slave trade and 2. make peace with France. It was now inevitable that the slave trade would be abolished; the Whig ascendancy and support for abolition made the outcome of any vote a forgone conclusion. Fox spent the last weeks of his life preparing the bill, which was presented to the Commons after his untimely death in September 1806. At the second reading on 23 February 1807 the motion for the abolition of the slave trade was passed 83 votes to 16, and received royal assent on 25 March 1807. Voting consistently in favour of abolition from 1792 was the MP for York, Wakefield man Richard Slater Milnes. Wakefield had been at the forefront of moves for the abolition of the slave trade. Revds Turner and Johnstone deserve much credit for taking the bold steps to support abolitionism when such views were deeply unpopular. We have much to celebrate in the life of these two men. Wakefield has both a dark legacy of slave ownership as well as a history to celebrate in its abolitionists.

Political Activism

As well as fighting to abolish the slave trade, Wakefield men and women sought to bring about a fairer society. An honorary son of our city, Richard Henry Lee, changed the world. Born in Maryland, Virginia, he was educated from the age of sixteen in Wakefield. From 1748 to 1753 he attended Queen Elizabeth Grammar School. He had family links to Wakefield: the Lee family worshipped at Westgate Common Protestant Dissenting Chapel, opened on 1 November 1697 and replaced by the current Westgate Chapel in 1752. The congregation and society he was part of were in opposition to the Crown, and among other things the Tory Party. Known as 'Whigs', these middle-class radicals argued, in the second half of the eighteenth century, for religious toleration, democracy, political reform to give towns like Wakefield, Leeds and Sheffield their own MP, and to limit the power of the Crown and the aristocracy. These radical ideas deeply impressed Lee when he returned to Virginia. Starting in 1774, Whigs in England began agitating to allow American colonies to have self-determination. Led by the Marquis of Rockingham and Pemberton Milnes of Wakefield, petitions across the country were managed from Westgate Chapel, in support of American independence, and also the abolition of slavery. As religious dissenters, who were legally second-class citizens in their own country, Unitarians and their political allies sought to end their own 'slavery', as well as that of slaves in bondage in America and across the globe, and also the right for the Americans to be free from what the Whigs understood to be an increasingly corrupt British Parliament. From 1763 to 1776, Parliament, King George III, royal governors, and colonists clashed over regulations of trade, representation, and taxation. Despite the growing unrest, many Americans perceived war and independence to be a last resort. Thomas Jefferson, whilst living in England, supported the Whig campaign, and sent words of support to the Unitarians at Westgate Chapel when 'Church and King' supporters attacked the chapel in 1774 over the congregation's support of America and also the campaign to bring about religious tolerance, and to give the same rights as enjoyed by Anglicans to dissenters. This did not come about until 1871, yet the campaign to end slavery bore fruit, allowing America to secede from the Crown. Fighting began in 1775 at Lexington between American colonists and Crown forces. In

America, well aware of the support from the Whig political group in England, Richard Henry Lee first proposed American independence on 7 June 1776. The text of the resolution stated:

> Resolved, That these United Colonies are, and of right to be, free and independent States, that they are absolved from all allegiance to the British Crown, and that all political connection between them and the State of Great Britain is, and ought to be, totally dissolved. That it is expedient forthwith to take the most effectual measures for forming foreign Alliances. That a plan of confederation be prepared and transmitted to the respective Colonies for their consideration and approbation.

Lee would sign the later Declaration of Independence. The war dragged on until the Treaty of Paris was signed in 1783, ending the war in favour of the American colonists, although the British still controlled Savannah, Charleston, New York, and Canada. Part of those negotiating on behalf of the Whig government headed by Lord Shelburne was David Hartley. Hartley from Hull – who we met earlier, involved in the movement to abolish the slave trade – was a close political ally of the Milnes family, and indeed John Milnes Jr had funded and been campaign agent for Hartley during the 1780 general election.

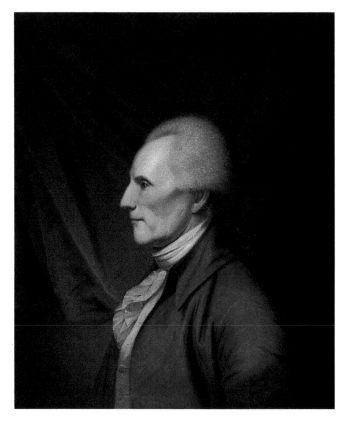

A forgotten son of Wakefield, William Henry Lee, a founding father of America.

From 1780, the Milnes family were amongst a group of political radicals who, with men like Major John Cartwright – the father of English democracy, and an honorary son of the city, as he was educated at Heath Academy – and Revd Christopher Wyvill began a campaign to reform Parliament and bring about universal suffrage. Political reform, as our earlier chapter notes, went hand in hand with abolition of the slave trade and holding the Crown to account.

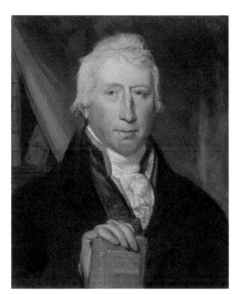 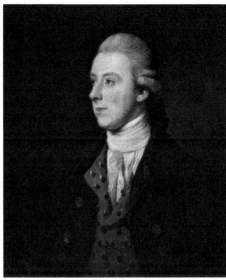

Above left: John Mines, aka Jack Milnes the Democratic. He was a radical politician and patron of the arts, who dominated the politics of Wakefield and the nation from 1770 until his death in 1810. He spent much of his £10,000 a year income from the wool trade on art – he was the last great patron of Joseph Wright of Derby. Many of Milnes' collection of Wrights can be found in Derby Museum and Art Gallery. So fond of art was Milnes, he built a 60-foot-by-30-foot extension to his Westgate mansion to house his collection, which included Rembrandts and Van Dykes of international importance. A self-confessed Jacobin and supporter of the French Revolution, he lived in Paris in 1791–93 at the centre of a circle of expats which included fellow Unitarians Mary Wollstonecraft, James Watt Jr, Helen Maria Williams and her lover John Hurford Stone, Benjamin Vaughan and the Wordsworths. He began a relationship with a penniless Irish orphan, Catherine Carr, whose father had been an Irish soldier in the service of France. Their son Alfred Washington Mirabeau Milnes was born on 21 April 1792 in Paris. Ostracised for his radical politics, his business failed, compounded by unfavourable trading conditions due to the Napoleonic Wars. He spent time in Canada where his elder brother was deputy governor general of Lower Canada. He and his family returned to Wakefield in 1806, and his wife died the same year, aged thirty-three. Almost penniless, Milnes lived at his grandmother's home, Meersbrook Hall in Sheffield, until he died, aged sixty-one, in 1810, leaving his sons nothing except his collection of genealogical records. Both he and Catherine lie beneath Westgate Chapel with their infant daughter Caroline.

Above right: James Milnes, builder of the long-demolished Thornes House, anti-slave trade campaigner, peace campaigner and friend of William Wilberforce. Milnes was influential in London social circles, along with his wife, Mary Anne.

The Milnes family again shot Wakefield to national importance in 1801 and again in 1808 and 1815 when they sent petitions for peace to end the Napoleonic Wars, the petitions being headed and organised by the congregation at Westgate Chapel. It was largely the same people, led by Revd Thomas Johnstone, who formed the Wakefield Reformers Association to agitate for political change that would lead to the Reform Act. Baptised in Wakefield at Westgate Chapel, Richard Monkton Milnes, grandson of Richard Slater Milnes, who lies beneath Westgate Chapel, would become Lord Houghton, an influential Victorian politician.

Throughout the period 1807–25, abolition of slavery had taken second place to political reform, and it was not until 1823, thanks in part to the lifting of the various 'gagging acts', that any progress was made when the London Society for the Mitigation and Gradual Abolition of Slavery was formed. Slave rebellions in 1816 and 1822 helped bring slavery back into focus in the public imagination. Thomas Clarkson had begun campaigning again in 1823, and within a year 250 anti-slavery societies had been formed – many of these societies were female. Inspired by Thomas Clarkson's efforts, slavery in Wakefield was dramatically thrust back into the limelight by a leading member of Westgate Chapel: Ann Hurst. At the start of May 1823, in her capacity as the temporary editor of the *Wakefield and Halifax Journal*, Mrs Hurst declared in her editorial that 'a false belief has very generally existed, that slavery had ceased, or is in a gradual state of abolition'. She called for a petition to be raised and an anti-slavery committee formed, which was headed by Revd Thomas Johnstone and included Unitarians like Frederick Gotthard, the Willans family, and the Gaskell brothers to name but a few – all were members of the Wakefield Reformers Association.

Ann Hurst, daughter of John Day, was baptised at Westgate Chapel by Revd William Turner on 15 March 1772. Day was an active member of the local Whig Association and subscribed to the Westgate Chapel Lending Library in 1768. Ann married Rowland Hurst I in 1798 at St John the Baptist Parish Church, Wakefield – it was illegal for Unitarians to marry in their own chapels until the 1830s. Rowland, following the death of Dr James Richardson in 1806, became Post Master of Wakefield. Richardson was physician to Wakefield Dispensary, an institution he and fellow Unitarians helped found in 1786. Hurst rented a printing business from the Post Officer premises on Wood Street, Wakefield. He bought out the *Wakefield Star* in 1811. The newspaper had been a joint venture between Thomas Lumb and Jack Milnes to provide the town with its own newspaper, the first edition appearing on 1 March 1803. In Leeds, the Milnes family financed Edward Baines to run the *Leeds Mercury*. Baines went on to found the 'Bainestocracy' of Mill Hill Chapel, and he and his family dominated Leeds politics. The Milnes and the Lumbs sought to emulate Baines and provide a mouthpiece for the radical left. Active freemason and Anglican priest Revd Dr Martin Naylor was appointed the editor. Naylor was linked with the Milnes family

through Whig politics and freemasonry: Richard Slater Milnes was Provincial Grand Master of Yorkshire in 1784 to 1804. Under the Hurst's ownership the paper became known as the *Wakefield and Halifax Journal and Yorkshire and Lancashire Advertiser*, the first edition being printed on 1 March 1811. Martin Naylor remained as editor until 1832, assistant editor, music and art critic being Revd Thomas Johnstone until his death. It was very much a Unitarian enterprise! Rowland Sr had converted to his wife's faith in the 1790s from the preaching and politics of the aforementioned Revd Johnstone. Rowland I died in 1823 aged forty-eight, and with his eldest son not yet in his majority, Mrs Hurst took over the running of the newspaper. Her son Rowland II would marry Marianne Johnstone in 1830, the daughter of Revd Thomas Johnstone. Using the pages of her newspaper and backed by the Wakefield Reformers, in 1825 an anti-slavery petition was raised by Mrs Hurst, which called for immediate abolition. The petition was drafted by Wakefield lawyer Twistleton Haxby. Ann Hurst died in 1832, her son Rowland taking over the newspaper two years earlier, the paper becoming the *Wakefield and Halifax Journal*. Rowland sold the paper in 1833 to Thomas Nichols, becoming the *Wakefield and West Riding Examiner* in 1849 and ceasing to exist in 1852 upon amalgamation with the *Wakefield Journal*. Ann Hurst, who died on 17 March 1832, was buried with her husband and four children in the Unitarian burial ground at Westgate End, Wakefield. Her mortal remains were moved to Wakefield municipal cemetery in the 1960s and placed in an unmarked mass grave with her husband, children, over 200 co-religionists as well as Revd William Turner. As a pioneering business owner and editor Mrs Hurst has been recognised with a blue plaque by Wakefield Civic Society who have been working with the Forgotten Women of Wakefield project. Rowland II would go on to be a leading light in Wakefield Whig politics and abolition and was named a trustee of Westgate Chapel.

As a result of Thomas Clarkson's renewed efforts, in 1825 a London society for the abolition of slavery was formed, with regional associations organised rapidly after, with Ladies' Associations established in Barnsley, Sheffield and later in Wakefield by Revd Carpenter of Northgate End chapel. This was the start of a new nationwide movement that submitted hundreds of petitions from Yorkshire to Parliament to appeal for the abolition of slavery, and women made a significant contribution. In Sheffield, two women collected the signatures of 187,000 in 1831. In Leeds some 6,000 crammed into the Coloured Cloth Hall to hear lectures against slavery. Between 1824 and 1831 it is reckoned some 3 million anti-slavery tracts were published, 500,000 in 1831 alone. Yet Parliament was unmoved on the subject. Despite the best efforts of Mrs Hurst and Westgate Chapel, it was not until the end of the 1820s that religious groups flocked to the cause. Through Edward Baines Jr of the *Leeds Mercury* and John Marshall – both Unitarians and members of Mill Hill – slavery became a hot topic in the election of 1826. Henry Brougham, another candidate, also backed abolition, and both were duly elected as MPs for Yorkshire. Richard Slater Milnes' grandson

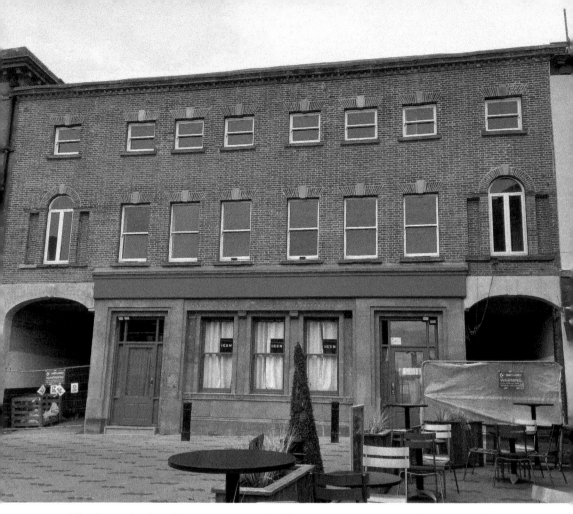

Thanks to funding from Historic England, Ann Hurst's Westgate home is undergoing essential repairs, and now stands as a fitting memorial to her life of political activism.

Marmaduke Wyvill MP, during his 1826 election campaign, reaffirmed his support for reform and Catholic relief, and declared himself an enemy of slavery. On 10 November 1830, under the chairmanship of Revd Dr Martin Naylor, the Wakefield Reformers Society organised a mass meeting calling for the abolition of slavery. Revd Thomas Johnstone sat on the platform alongside Joseph Gosnay, the Methodist Chief Constable. With the passing of the Reform Act, Wakefield could return an MP. The Wakefield Reformers chose Daniel Gaskell as their candidate. One of the first acts of the reformed parliament was to abolish slavery. The Abolition of Slavery Bill was passed in August 1833, although it did not grant freedom. Slaves under the age of six were automatically freed and those over the age of six were apprenticed to their masters for six years with little to no change in their working conditions and working for no wage. The whole exercise to many, including Daniel Gaskell, was a vast exercise in slave trading if giving millions in compensation: freedom was bought and each slave had a price on their head.

Some £20 million was paid in compensation: the rich got richer and the slaves received nothing except more years of toil and labour. Lord Harewood, already astronomically wealthy, received £26,309 in compensation.

Abolitionism fed into wider political awareness. Thanks to the reform bill, Daniel Gaskell was elected MP for Wakefield. The 1832 Reform Act granted the vote to about 10 per cent of the population. Dissatisfaction with this led to increased political radicalism to bring about sweeping social change. These men and women were known as Chartists. One of the leaders in Wakefield was Revd John Cameron, the minister at Westgate Chapel. He led a movement to found a workingman's political and educational movement. Another was Joseph Horner, a congregationalist local preacher, passionate supporter of the abolition of the slave trade and leading Chartist. He was commemorated with a stone monument erected in the grounds of the Unitarian School Rooms on Back Lane in 1850 for his activism in ending the feudal obligation of the Wakefield Soke and Church Rate. Horner, as a Nonconformist, was opposed to paying taxes for the upkeep of the parish church and its clergy, and as a corn miller resented having to grind his corn at the Wakefield Soke Mill and not his own premises. The Church Rate was abolished in 1848 and the Soke in 1853, the year of Horner's death.

Daniel Gaskell, the Unitarian 'Uncanonised patron saint of Wakefield' whose wealth was instrumental in building Clayton Hospital.

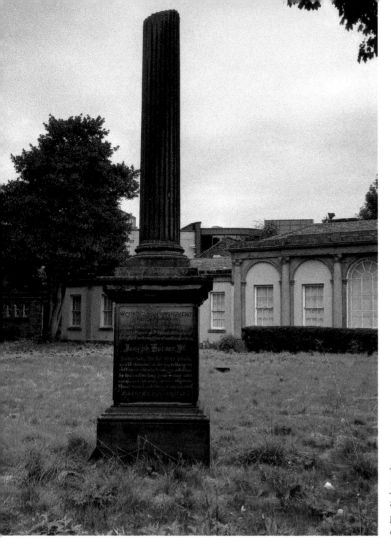

The monument of chartist Joseph Horner and all workingmen in the grounds of the Orangery on Back Lane.

In the year Horner died, slavery lingered on in America. In Leeds Revd Charles Wicksteed, the minister at Mill Hill, was the devoted servant to abolitionism. When Frederick Douglass – an escaped slave – and Henry Clarke Wright spoke in Leeds in 1847, Wicksteed was the only minister of religion present! Wicksteed was joined in his abolitionist crusade by Revd Russell Lant Carpenter, minister at Northgate End Unitarian Chapel, Halifax, and began a highly vocal campaign across the country. He encouraged the formation of abolitionist societies. He was joined by a Mrs Griffiths, who promoted the formation of 'Ladies Abolition Societies'. From 1858, the communist poet and chartist Revd John Goodwyn Barmby became minister at Westgate. He had been a strident abolitionist since the 1840s and had met Frederick Douglass in London in 1847, at a meeting with Charles Dickens no less, and would do so again in Wakefield in 1860 whilst Douglass was hosted by the Carpenters in the parsonage at Northgate End along with Sarah Parker Remond. Frederick Douglass, Miss Remond and Revd Barmby spoke passionately in Wakefield at the long-demolished Corn Exchange. From this

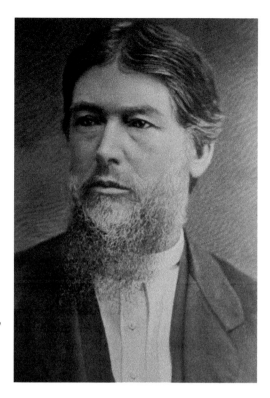

Revd John Goodwyn Barmby, minister at Westgate Unitarian Chapel, 1858–1881, political radical and outspoken critique of slavery, who spoke in the Corn Exchange alongside former slave Frederick Douglass.

came a new anti-slavery campaign, led by women, amongst whom we find diarist and Unitarian Clara Clarkson.

Abraham Lincoln ended slavery in America on 18 December 1865. Wakefield men and women had done their bit to support Lincoln's vision of a free world. Barmby was a communist, debated political theory with Marx and Engels, and fought in the French Revolution of 1848. His first wife, Catherine, was the first female radical journalist since Mary Wollstonecraft's death. Her suffrage petition of 1843 brought her national fame and condemnation. Barmby garnered support for the 1866 Suffrage Petition to Parliament, which was signed by nine members of the congregation. In 1867 he held a mass rally in Wakefield for universal suffrage. He was invited by Lydia Becker to assist the foundation of the Manchester Society for Female Suffrage, and put the French feminist Anne Knight into contact with Lydia. It is fair to say that without the largely forgotten Barmby family, the suffrage movement that the Pankhursts became involved with would not have been as well organised and effective as it was. In 1868 Revd Barmby and his wife Ada founded the Wakefield branch of the Manchester Society, the first such female suffrage society in West Yorkshire, with his daughter Julia as secretary. He held rallies and lectures in Wakefield from 1868 until his retirement in 1880. In 1872 Miss Julia Barmby, as secretary, invited the lecturer and active suffragist for the National Society, Madame Ronniger, to speak on the Parliamentary enfranchisement of women to a 'small but very attentive audience'. A decade

later in April 1882, Wakefield received a visit from Alice Scatcherd, a Unitarian attending Mill Hill Chapel, Leeds, alongside a group of speakers including Laura Whittle from Liverpool and Revd John Wolstenholme. Revd Barmby had suffered a stroke on Christmas Day 1879 and retired from his role at Westgate Chapel in spring 1880, the family leaving the town over the summer to go back to Barmby's native Suffolk, and the diligent efforts of the Barmby family to introduce the suffrage cause to Wakefield lapsed. However, the branch was refounded in 1904, and again in 1910 by Florence Beaumont, who used her home as the ideal location to host discussions on suffrage, reigniting the work of the Barmby family in the area. The branch grew quickly, with a reported fifty members by April 1910, and the confirmation of affiliation with the National Union was reported a month later. Suffrage support was cemented in the area by a resolution passed by the Wakefield Trades and Labour Council in support of women's suffrage, followed by an outpouring of assistance in the form of open-air meetings, distribution of literature and copies of resolutions to parliamentary parties by the trade unions. In addition, support was shown by the *Wakefield Express*, reporting on the 'non-militant, non-party' meetings, but also from the local Members of Parliament who had both voted in favour of the Representation of the People (Women) Bill in May 1913. Yet the suffragettes were opposed by vocal and violent adversaries. Only 58 per cent of the adult male population was eligible to vote before 1918. An influential consideration, in addition to the suffrage movement and the growth of the Labour Party, was the fact that only men who had been resident in the country for twelve months prior to a general election were entitled to vote.

The Bond Street home of Florence Beaumont, the re-founder of the female suffrage movement in Wakefield whose life and work was honoured with a blue plaque. Born on 17 June 1876 in Stanley, from a young age she set her sights on securing all women the right to vote. Despite not actively seeking power for herself, her unwavering will and unshakable morality propelled her to prominence, and she founded and helped run several women's rights and suffrage organisations. Florence was among those chosen to represent the women's voice at the League of Nations in 1928. Florence died unexpectedly a year later, cutting short her remarkable life but not her legacy, which lives on today in every woman when they exercise their political power.

This effectively disenfranchised a large number of troops who had been serving overseas in the war. With a general election imminent, politicians were persuaded to extend the vote to all men and some women at long last.

In 1918 the Representation of the People Act was passed, which allowed women over the age of thirty who met a property qualification to vote. Although 8.5 million women met this criterion, it was only about two-thirds of the total population of women in the UK. The same Act abolished property and other restrictions for men, and extended the vote to virtually all men over the age of twenty-one. Additionally, men in the armed forces could vote from the age of nineteen. The electorate increased from 8 to 21 million, but there was still huge inequality between women and men. It was not until the Equal Franchise Act of 1928 that women over twenty-one were able to vote and women finally achieved the same voting rights as men. This act increased the number of women eligible to vote to 15 million.

This does not mean that social activism in Wakefield is a thing of the past: since the 1970s Unitarians and others in Wakefield have been at the forefront of LGBTQI+ rights, and Wakefield Unitarians were prominent in the part the national Unitarian denomination played in making same-sex civil partnerships and same-sex marriage in a church legal in 2013. Unitarians have long supported lesbian, gay, bisexual and transgender rights, and we are proud to provide marriage ceremonies for all couples. In fact, Unitarians were one of the first churches to offer same-sex marriages.

In 2012, Unitarians made history when Cross Street Unitarian Chapel in Manchester became the first place of worship to register for civil partnerships and Ullet Road Unitarian Church in Liverpool conducted the first religious same-sex civil partnership in the UK. When the law changed to allow same-sex marriages, many Unitarian congregations were among the first to register to offer them too. Today, most of the 160 plus Unitarian churches, chapels and meeting houses in the UK are now registered to conduct same-sex marriages. The author has conducted these ceremonies at the city's historic Westgate Chapel. For their activism, both Ann Hurst and Florence Beaumont have been commemorated with blue plaques as part of the Forgotten Women of Wakefield project.

5

The Arts

Wakefield has been home to artists and writers alike. The standout man of words in Georgian Wakefield was Thomas Amory (c. 1691–25 November 1788), a writer of Irish descent. In 1755 he published *Memoirs: Containing the Lives of Several Ladies of Great Britain. A History of Antiquities* and *Observations on the Christian Religion*, which was followed by the *Life of John Buncle, Esq.* The work is a collection of Buncle's 'memorandums of everything worth noticing', including philosophical, mathematical, and theological musings. But at a deeper level, it is also a work of Unitarian theology, which seeks to persuade its reader of the importance of rational enquiry. The pioneering remainder bookseller James Lackington claimed that he had been converted from 'a poor ignorant, bigoted, superstitious Methodist' by reading the book, as it had forced him to 'reason freely on religious matters'. And it was celebrated in the Romantic period by such authors as William Hazlitt (who described Amory as 'the English Rabelais'), Charles Lamb and Leigh Hunt. Despite the considerable interest in Buncle in the eighteenth century and Romantic period, the novel is now almost entirely unknown, even to specialists in eighteenth-century fiction. In life Amory was a renowned eccentric and scarcely ever stirred abroad except at dusk. He moved to Wakefield to live with his son Dr Robert Amory (1720–1805) by 1783. Robert Amory was a physician in Wakefield for twenty-seven years and a governor of Wakefield Grammar School. He was a student of medicine, geology, and antiquities, and filled his writings with a variety of information on these and other subjects. He and his son attended Westgate Chapel for over a decade but is largely forgotten in his adopted home.

Contemporary with Amory was co-religionist Esther Milnes Day, who was one of the first women poets to have her work published. As a pioneering feminist author, she blazed a trail which Jane Austen, Anna Barbauld and others followed.

Another from the Westgate Chapel congregation with strong links to literature was Revd John Goodwyn Barmby, who we met earlier. Born at Yoxford in Suffolk, he was baptised on 12 November 1820. His father, John, a solicitor, married Julia, who died when Goodwyn was fourteen years old. Goodwyn never used his first Christian name, had no formal school education but read widely. He

eschewed the professions and followed a career of social and political radicalism, reputedly addressing small audiences of agricultural labourers when aged sixteen or seventeen. Barmby claimed credit for founding the East Suffolk and Yarmouth Chartist council in September 1839. In December he was elected delegate to the Chartist convention and in 1840 and 1841 he was re-elected, though alienated from political radicalism by this time. Already a correspondent of the Owenites' New Moral World (writing on language reform and Charles Fourier), in 1840 he visited Paris with a letter of introduction from Owen, and in 1840 he visited Paris, living in the students' quarter, and examining for himself the social organisation of the French capital. Here he claimed to have originated the now famous word 'communist' as a translation of the French word communiste and popularised the word and its ideals with zeal and fervour. It was Goodwyn Barmby who introduced Engels to the French Communiste movement. Barmby set out to capitalise on the pseudo-Christian undercurrents running through socialism, declaring in his revised creed: 'I believe ... that the divine is communism, that the demoniac is individualism...'

Calling himself 'Pontifarch', he announced that he had joined Judaism and 'Christianism' to produce the synthesis of the Communist Church. He devised a four-staged baptismal rite (to symbolise the four stages of history leading to the paradise of universal communism), followed by an anointing with oil. The subtitle of his journal is indicative of his general approach: The Apostle of the Communist Church and the Communitive Life: Communion with God, Communion of the Saints, Communion of Suffrages, Communion of Works and Communion of Goods. Barmby's explicit infusion of Christian terminology with socialist ideology was adopted by communist propagandists throughout Europe. Communism was touted as the means of bringing to fruition the Christian call for brotherly love. Christ was portrayed trampling the serpent of 'egoism' beneath His feet, surrounded by an army of angels sporting the red caps of the French Revolution. On 13 October 1841, Barmby founded the Communist Propaganda Society and designated 1841 Year 1 of the new communist calendar. The Universal Communitarian Association followed, promoted by the monthly *Educational Circular and Communist Apostle*. In 1842, he founded and almost single-handedly wrote the monthly *Promethean, or, Communitarian Apostle*, which also promoted rational marriage and universal suffrage, and lectured at the 'communist temple' at Marylebone Circus, Marylebone, Middlesex. Out of this activity and through his contact with James Pierrepont Greaves (with whom he published the *New Age, or, Concordian Gazette*, the journal of Greaves's own Ham Common community), Barmby established the Moreville Communitorium at Hanwell in 1842. The following year, he issued his *Communist Miscellany*, a series of tracts written by himself and his wife, and founded the weekly *Communist Chronicle*, which also supported the German communist Wilhelm Weitling.

He soon attracted the backing of radical chartist journalist Thomas Frost. With Frost's backing he wrote *Book of Platonopolis* combining utopian ideals and

scientific projections of a future state of mankind including a people's car powered by steam. However, Frost soon tired of Barmby's sectarianism and unbridled utopianism, and Frost separated from him in 1846 to establish the *Communist Journal*. Frost's competition with Barmby destroyed both journals but Barmby continued to proselytise in *Howitt's Journal*, and contributed to the *People's Journal*, *Tait's Magazine*, *Chambers's Journal*, and other periodicals. Barmby wrote several volumes of pastoral poetry: 'The Poetry of Home and Childhood' (1853), 'Scenes of Spring' (1860), and 'The Return of the Swallow' (1864). His devotional works included 'Aids to Devotion' (1865), the 'Wakefield Band of Faith Messenger' (1871–79), which was committed to the advance of theological liberalism, and a large number of hymns and tracts. He was minister at Westgate Chapel from 1858 to 1880. He died in 1881, aged just sixty. In Wakefield, he was a member of the Mechanics' Institute. Here he came into contact with another Wakefield writer, Thomas Waller Gissing.

Gissing, not a native of Wakefield, was a chartist and wrote for the *People's Journal*, and thus would have known of Goodwyn Barmby before both men met in Wakefield. Like Barmby, Gissing endeavoured to unite his political and poetical ideas. Both men were active in the Mechanics' Institute and Wakefield Liberal Association. Barmby subscribed to Gissing's *The Ferns and Fern Allies of Wakefield* of 1862. Gissing's son George and daughters were also prolific in their education and literary endeavours. George, born in Wakefield in 1857, was educated at the Unitarian School in Back Lane, where he was a diligent and enthusiastic student. His serious interest in books began at the age of ten when he read *The Old Curiosity Shop* by Charles Dickens and, subsequently, encouraged by his father and inspired by the family library, his literary interest grew. Thomas Gissing died when George was twelve years old, and he and his brothers were sent to Lindow Grove School at Alderley Edge in Cheshire, and in 1872, after an exceptional performance in the Oxford Local Examinations, Gissing won a scholarship to Owens College, forerunner of the University of Manchester. Gissing's academic career ended in disgrace when he ran short of money and stole from his fellow students. The college hired a detective to investigate the thefts and Gissing was prosecuted, found guilty, expelled and sentenced to a month's hard labour in Belle Vue Gaol, Manchester, in 1876. He published extensively; early novels were ill-received, but greater recognition came in the 1890s in England and overseas. The increased popularity affected his novels, the short stories he wrote in the period, and his friendships with influential, respected literary figures such as the journalist Henry Norman, author J. M. Barrie and writer and critic Edmund Gosse. By the end of the century, critics placed him with Thomas Hardy and George Meredith as one of three leading novelists in England. George Orwell admired him and in a 1943 *Tribune* article called him 'perhaps the best novelist England has produced', believing his masterpieces were the 'three novels' *The Odd Women*, *Demos*, and *New Grub Street*, and his book on Dickens. His sisters Margaret and Ellen were as equally exceptional and have been honoured with a blue plaque.

The Westgate chemists shop of Thomas Waller Gissing is now NatWest Bank. He was father of a notable family influential in literature and education.

The Gissing family home is now the Gissing Centre, a study centre established to explore the legacy of the family.

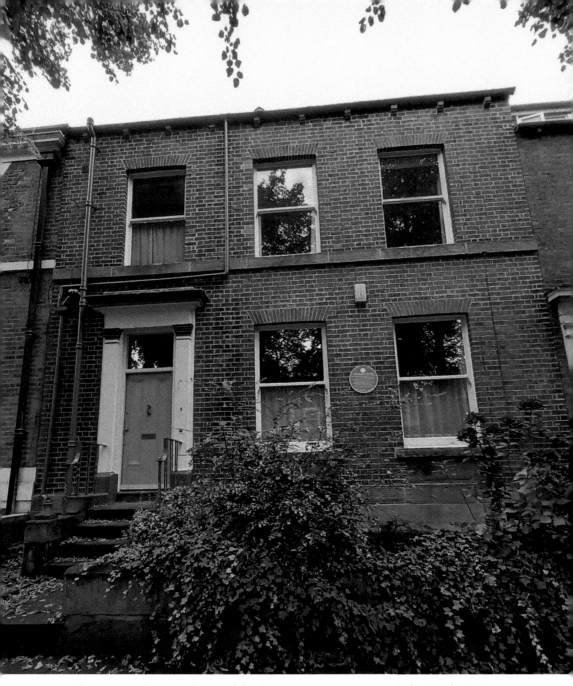

The Wentworth Terrace home of the Gissing sisters. Margaret 'Madge' Emily Gissing was born in 1863, followed by her sister Ellen 'Nellie' Sophia Gissing in 1867 at the chemist shop at No. 60 Westgate, Wakefield.

While their brother George has earned standing as an author, the sisters were constrained by social attitudes of the time. Despite having fewer opportunities than men, the sisters founded the Wakefield Boys' Preparatory School in 1898, which existed for fifteen years before closing when the sisters moved from Wakefield to Leeds in 1912. In addition to the core subjects of reading and arithmetic, the Gissing sisters included sport, music and learning foreign languages in their curriculum.

Internationally known musician and composer Kenneth Leighton was born in Wakefield in 1929. He was chorister at Wakefield Cathedral. Encouraged by his mother and the parish priest (who helped obtain a piano for the family), he began piano lessons and progressed precociously. In 1940, he gained a place at Queen Elizabeth Grammar School, played at school assemblies and concerts, and composed settings of poetry for voice and piano and solo piano pieces, his first piece being published in 1946 whilst still at school. He later studied at Queen's College, Oxford, graduating with both BA in Classics and BMus, having studied with Bernard Rose. In 1955 he was appointed Lecturer in Music at the University of Edinburgh where he was made Senior Lecturer, Reader, and then Reid Professor of Music in October 1970. Kenneth Leighton was one of the most distinguished of the British post-war composers; over 100 compositions are published, many of which were written to commission, and his work is frequently performed and broadcast both in Britain and in other countries, yet is largely forgotten in his home city.

A fellow chorister at the cathedral was Reginald Moxon Armitage, who was born in Wakefield in 1898. He was educated at Queen Elizabeth Grammar School

Kenneth Leighton, a son of Wakefield who became an internationally known musician.

before obtaining a scholarship at the age of fifteen to attend the Royal College of Music in London, after which he attended university. Precociously talented, he had deputised for the choirmaster of Wakefield Cathedral from the age of eight, becoming honorary deputy organist at twelve. He had become music director and organist at St Anne's Church in London's Soho district by the age of eighteen. Whilst at Cambridge, Armitage's interest in religious music and composition declined as his passion for musical comedy grew. He began writing popular songs, using the stage name Noel Gay, and contributed the music but not the lyrics to the 1937 West End show *Me and My Girl*. Gay went on to write songs for revues by The Crazy Gang, and for star artists like Gracie Fields, Flanagan and Allen and George Formby, as well as penning popular Second World War songs such as 'Run Rabbit Run'. He died in 1954.

Phyllis Burgh Ker (née Lett) was born in Lincolnshire in 1883, and was educated at Wakefield Girls' High School from 1894 to 1900. She studied at the Royal College of Music, and in Paris she achieved distinction as a professional contralto singer and recording artist, particularly in the period 1906–25. As a mezzo-soprano, Lett was a popular recitalist during the 1920s. *The Times* reports that she 'had a pleasing voice of even quality, intelligence and interpretation and persuasive delivery'. Phyllis worked with the most distinguished musicians of the day, including Sir Edward Elgar and Sir Henry Wood, and was a major performer at the Proms in 1913, 1914 and 1915. During the First World War she supported the national effort in over 1,000 concerts at home, in France and in Belgium.

Reginald Moxon Armitage, aka Noel Gay, a famous son of Wakefield who was an internationally known musician.

Radio and the gramophone were increasingly important and Phyllis embraced both. She married Charles Rupert de Burgh Ker in 1924 and the newly married couple moved to Australia in 1925. She died at Yea, Victoria, Australia, in 1962. A blue plaque to her memory was unveiled on the family home on South Parade.

Heir to Phyllis Lett is the singer and TV personality Jane McDonald. Born and raised in Wakefield, McDonald spent much of her early career performing in local clubs and pubs before landing work as a singer on cruise ships. McDonald became known to the public in 1998 following her appearance on the BBC show *The Cruise*. The album *Jane McDonald* spent three weeks at Number 1 in the UK Albums Chart, while the single 'Cruise into Christmas' (a medley of Christmas classics) reached the UK Singles Chart Top 10. In 2011 Wakefield Council awarded her a star in the form of a pavement plaque for outstanding achievement from an entertainer and in 2018 McDonald was awarded a British Academy Television Award for her television series *Cruising with Jane McDonald*.

Born in 1933, David Malcolm Storey was a novelist, playwright and screenwriter, winning the Booker Prize in 1976. Following his attendance at Queen Elizabeth Grammar School, he continued his education at London's Slade School of Fine Art. He wrote the screenplay for *This Sporting Life* (1963), directed by Lindsay Anderson, adapted from his first novel of the same name, originally published in 1960, which won the 1960 Macmillan Fiction Award. The film was shot largely in his native city. The film was the beginning of a long professional association with Anderson, whose film version of Storey's play *In Celebration* was released as part of the American Film Theatre series in 1975. *Home* and *Early Days* (both

Phyllis Lett was born in Lincolnshire, but educated at Wakefield Girls' High School (1894–1900). After studying at the Royal College of Music and in Paris she achieved distinction as a professional contralto singer and recording artist, particularly in the period 1906–25. Phyllis worked with the most distinguished musicians of the day, including Sir Edward Elgar and Sir Henry Wood, and was a major performer at the Proms in 1913, 1914 and 1915.

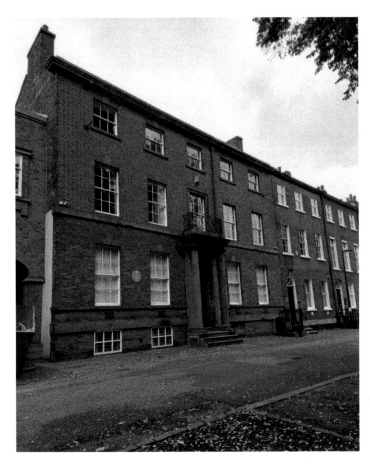

The South Parade
home of Phyllis
Lett during her
time in Wakefield.

starred Sir Ralph Richardson, while Home also starred Sir John Gielgud) were
made into television films. Storey's novel *Pasmore* was shortlisted for the Booker
Prize. Storey died on 27 March 2017 in London at the age of eighty-three and was
buried on the eastern side of Highgate Cemetery.

The first woman recipient of a major Pulitzer Prize in journalism and first
woman to join the editorial board of *The New York Times* was born in Wakefield
in 1880: Anne O'Hare McCormick.

In the sphere of art, Louisa Fennell, honoured with a blue plaque, was a
pioneering female artist. Born in Wakefield in 1847, Fennell was a watercolourist
who exhibited widely in the north of England. For example, her watercolour entry
to the 1884 Spring Exhibition in Derby was singled out by the local newspaper
as 'particularly noticeable'. Fennell is known for her watercolour paintings of
local Wakefield scenes, which include Wakefield Cathedral and Wakefield Chantry
Chapel at the turn of the twentieth century (1898–1904), as well as Sandal Castle,
painted in 1876, prints of which were donated by the owner to Wakefield City Art
Gallery and more recently to the Hepworth Gallery. Later Fennell painted views
of other cities, in particular Micklegate and Monk Gate in the city of York. She

died in 1930 and a retrospective exhibition of her work was held at Wakefield City Art Gallery in September 1936.

Perhaps the cities best-known past resident was Barbara Hepworth. Born in 1903, her father was a surveyor for West Riding County Council, and Hepworth accompanied him on his inspections of local roads and bridges. At Wakefield Girls' High School Hepworth was inspired by seeing images of Egyptian sculptures and, encouraged by the headteacher, Miss McCroben, applied for a scholarship to Leeds School of Art. Following this, in 1921 she began her studies at the Royal College of Art in London. On completing her degree in 1924, Hepworth was awarded a West Riding travel scholarship, enabling her to travel to Italy. She learnt to carve from a master-carver in Rome, where she met her first husband and fellow artist John Skeaping. Hepworth moved to St Ives in 1939, the same year she began making stringed sculptures. As seen in her 'Landscape Sculpture' works of the late 1940s, Hepworth connected these forms to nature, noting 'the strings

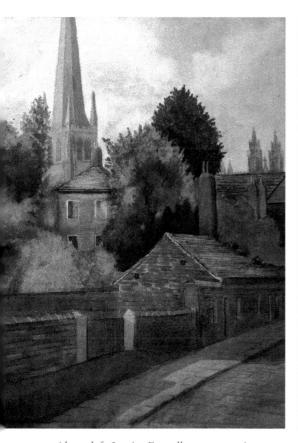 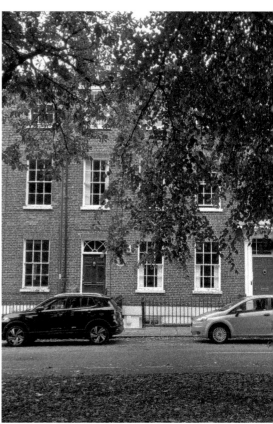

Above left: Louisa Fennell was a prominent watercolourist, and this previously unpublished example of her work shows Almshouse Lane.

Above right: The St John's Square home of Louisa Fennell.

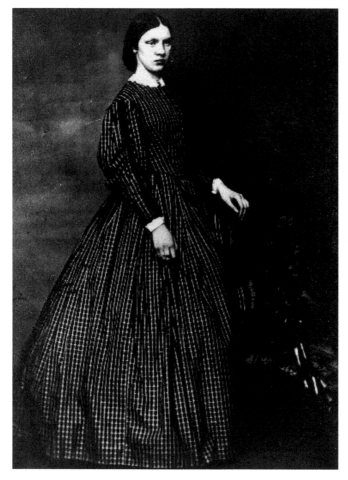

Louisa Fennell was born on 30 September 1847 to William Fennell and Mary Fennell (née White). Her maternal family attended Westgate Chapel in Wakefield and her grandfather Richard Fennell was a merchant in London and latterly in Leeds, trading as Fennell and Hainsworth. A Unitarian, he was in business with fellow trustee at Mill Hill Chapel, Leeds, Thomas Hainsworth. Richard Fennell left that partnership when Hainsworth formed a new concern, Hainsworth, Thursby and Dunn, which brought three Mill Hill trustee families together. Today that firm is Abimelech Hainsworth & Co. of Pudsey. Fennell's involvement in the wool trade meant that a lot of his wealth was based on importing slave-produced goods into Yorkshire. His granddaughter, Louisa, showed an early talent for art and in 1865, when she was just eighteen, received a First Class Medal at the Wakefield Industrial and Fine Art Exhibition. She entered art school not long after and then embarked on what would become a distinguished art career. This was despite the male-dominated art world providing fewer opportunities for women.

Like her father, it appears Louisa was also a keen diarist and often wrote about her visits to different parts of the UK and Europe and what inspired her there. Louisa was a private person who let her work and talent speak for her rather than attending rallies and political meetings. Nevertheless, she provides a landmark for women in the arts. Louisa continued to paint right into her twilight years, before finally succumbing to a heart condition at the age of eighty-two.

were the tension I felt between myself and the sea, the wind or the hills'. Living in close proximity to the countryside, Hepworth reflected in 1946, 'the main sources of my inspiration are the human figure and the landscape; also the one in relation to the other'. In 1951, Hepworth had a solo exhibition at Wakefield Art Gallery, which toured to York and Manchester. Hepworth was prolific during her later years, making nearly as many works during the 1960s as between 1925 and 1960. She died in 1975.

An honorary Wakefield man, Wilfred James Emery was born in Malmsbury, Wiltshire, in 1904. A prodigious young talent, he completed his degree in science at Bristol University aged twenty, and in 1925 became an Associate of the Royal College of Organists, winning the Sawyer Prize that year. He came to Wakefield that same year to take up the position of Director of Music at Thornes House School, where he also taught mathematics. From 1925 to 1927 he was organist at Westgate End Wesleyan Chapel, and then took up post as Director of Music at the influential Mill Hill Unitarian Chapel in Leeds. During his tenure he wrote choral music for the choir, notably a variation on *This Endris Night*. He left Mill Hill and Wakefield in 1930 to take up post at St Wilfred's School, Bradford. During this time he studied for a music degree at University College London, graduating in 1933. In 1936 he was appointed Director of Music of Glasgow Presbyterian Cathedral – a faith broadly similar to the Unitarianism he embraced at Mill Hill. Whilst in Glasgow he wrote numerous pieces of both choral music and organ music, which are still being performed today across Europe and North America. He died on 31 May 1964 on a bus on his way to choir practice at the height of his powers, and is celebrated internationally. He married Mary Archer, daughter of Wakefield industrialist James Archer, and is inter alia the authors great-great-uncle. The author and his twin carry on the families musical legacy: the author is privileged to play the organ from time to time at Mill Hill Chapel, carrying on the family tradition of both being a church organist, but also a Unitarian of the Free Christian variety, like Kate Taylor, John Goodchild and many other Unitarians mentioned in this book.

They Also Served

As well as prominent people in the arts, Wakefield men and women have also played their part in education and philanthropy.

Robert Sharpley, a town councillor for Wakefield for over twenty years, had premises on Marygate and then Silver Street as a clothier selling blankets and second-hand furniture. A few doors down Silver Street we find Jeremiah Dunnhill, director of music at Westgate Chapel from 1876 to 1922. He was of humble origins in that both father and grandfather were coachmen. A convert to Unitarianism through the preaching of Revd Barmby, in his letter to the chapel committee to seek membership, Sharpley reported that he had been deeply moved by the Christian-communist ethos of Revd Barmby, and his infusion of spiritual activism to bring about good works in the here and now. So moved by Revd Barmby, Robert Sharpley endeavoured to act out his faith through good works in Wakefield. The *Wakefield Express* on 15 February 1879 reported that during the cold weather every winter, Sharpley fed the needy poor. The *Express* noted that outside Councillor Sharpley's shop 'All who are in distress or destitute flock to his shop and the funds at his command fluctuate considerably but when funds will allow, all have something given to them to stave off the pangs of hunger. Each of the applicants who have been gathering for over an hour at 9.30 in the morning, receives a two pound loaf.' The *Wakefield Express* reported that each week 650 to 700 women and twenty men gathered outside No. 15 Silver Street waiting for the bread to be delivered. The report continues that

> Mr Sharpley acts as marshall, keeping the centre of the street clear. The cart arrives, rounds the corner of the shop front, backs and draws up. The crowd push and press upon the cart and upon Mr Sharpley who implores and threatens and eventually declares he will only give to applicants coming from his left. The men have been informed that they must wait till the last. Some people are infirm and pitiable to see, some carry babies. Mr Sharpley distributes the loaves quickly, the women take their bread, cover it with their shawl and extricate themselves and march home; some do not and 'like Oliver' want more and go round to the back of the queue. The crowd, however, is thinned very rapidly, in less than half an

hour the men are reached and despatched and soon there is no trace of the busy scene. Mr Sharpley is left to pursue his ordinary avocations. What others would regard as most irksome and disagreeable labour, contending philanthropically with the most rude and rough elements of our lowest 'residuum' he seems to relish and enjoy, no doubt feeling he is doing good to those who most need attention and succour.

Sharpley was indeed the good Samaritan of Wakefield. How many families living today owe their existence to Bob Sharpley's generosity of spirit? Over 700 loaves a week were supplied by fellow co-religionists the Websters, from their bakery a little further along Westgate. Every Christmas Eve, Sharpley provided food to all those that asked. The *Wakefield Express* reports that at Christmas 1875 he provided 1,000 free meals. He maintained this tradition for over thirty years. The *Express* reported that aged forty-five, he had to retire as a councillor due to ill health. He was thanked for his commitment to political reform and liberalism in Wakefield, and was presented with £600 and a vote of thanks by R. B. Mackie, leader of the Liberal Party in Wakefield, in front of a crowd of 10,000. From his own pocket, Sharpley provided a meal for all those who came to the meeting. We note that Revd Barmby was a fellow town councillor and both men liberally supported the Mechanics' Institute. On his death on 16 March 1885, when his passing came to be known by his fellow councillors, the bell of the Town Hall peeled to mark the sad occasion. His funeral service at Westgate Chapel was led by Revd J. Collins Odgers on 21 March, the chapel being greatly crowded by well-wishers. The chapel bell tolled during the service and Westgate was crowded with those unable to be present in the chapel. The street was hung with black drapery. He is buried in the grounds of the Orangery, Back Lane.

As well as councillor and benefactor of the poor, Bob Sharpley was also known as a tulip grower. Because he died at the early age of fifty-five in 1885, his exhibiting at the shows was over a very short period, perhaps as little as five years. However, he was very successful during this period and also at the Manchester shows of the Royal National Tulip Society. He grew the tulips in the extensive garden of his house, which was on Northgate near Clayton Hospital, and grew an estimated 700 tulips a year.

Before the national health service, healthcare was often provided by charities. Founded in 1826, the Wakefield House of Recovery on Lawefield Lane was funded by an annual dance and fundraising activities by the charity's trustees, led by its treasurer Margaret Heywood and other ladies connected with Westgate Chapel.

Another unitarian from Westgate Chapel who did more than any other person to preserve and research the history of Wakefield was John Goodchild. Born in Wakefield, the son of Ernest Goodchild, deputy registrar at the West Riding Registry of Deeds, and his wife, Muriel (née Lee), John attended the city's Queen Elizabeth Grammar School. On leaving full-time education, he went to work

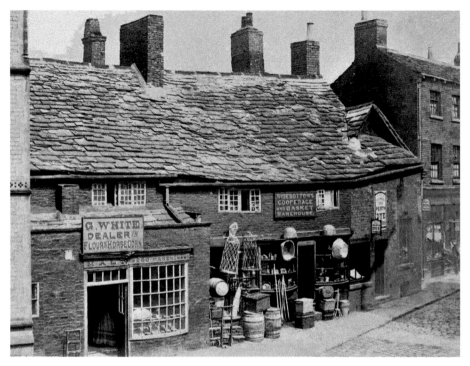

From a small shop with its gable facing Marygate, Robert Sharpley sold clothing and cloth to the poor of Wakefield.

Above left: Robert Sharpley, whose photographic portrait formerly hung in the vestry of Westgate Chapel.

Above right: The monument erected to 'the people's Bob' in the Unitarian burial ground in Back Lane.

Right: The handsome memorial
tablet to Robert Sharpley
erected in Westgate Chapel.

Below: The Wakefield House
of Recovery was managed by
Margaret Heywood from 1826
until her death in 1855.

in the West Riding Record Office – even then, he ran a private museum, at first housed in a local chapel, open to all-comers.

In 1966 he became founding curator of Cusworth Hall Museum, near Doncaster, which is devoted to the social history of South Yorkshire. Subsequently it won a Museum of the Year award for educational work. Some nine years later, he returned to Wakefield as first district archivist and principal local studies officer.

However, it is his collection of manuscript material and books, the boyhood interest that became his lifelong passion, that will be his lasting legacy. Put together from private purchases as well as donations from individuals, institutions and companies, the John Goodchild collection was the most substantial collection on Yorkshire and industrial history in private hands.

It includes manuscripts, books, maps, portraits and illustrations from the twelfth century onwards, and is especially rich in material from the eighteenth and nineteenth centuries. John always made the collection accessible, interpreting and using it for the benefit of researchers, and it will be maintained in the care of the West Yorkshire Archive Service.

John was a member of the Yorkshire Archaeological Society (and a co-founder of its industrial history section) and of the Wakefield Historical Society, which he served as vice-president. In 1984 he was awarded an honorary master's degree by the Open University for 'academic and scholarly distinction, and for public services'.

John was a familiar figure in Wakefield, often accompanied by one of a succession of rescue dogs. He is survived by Alan, his partner of sixty years. Throughout his life he was a Unitarian and ardent supporter of Westgate Chapel.

Revd Andrew Chalmers was born in Fetterangus, Scotland. He was appointed at Westgate Chapel on 15 June 1880. He married Mary Elizabeth Marriott on 21 April 1881, the daughter of the chapel president T. W. Marriott. The service was led by Professor Revd Dr J. Estlin Carpenter of London, late of Mill Hill Chapel, Leeds. Carpenter was one of the most important and influential Unitarians of the era.

Revd Chalmers was, like his predecessor Revd J. B. Barmby, an ardent supporter of the Mechanics' Institute, Clayton Hospital, lectured for the Paxton Society, as well as being vice-chairman of the School Board. Chalmers himself was born in 1840 and was educated at the universities of Heidelberg and Berlin and thence undertook ministerial training at Manchester College, Oxford. His first appointment was at Oldham, where he was responsible for the construction of the new chapel. From Oldham, he moved to be minister at Cambridge, which was then a relatively new congregation. In August 1879 he headed to Transylvania and left a vivid account of his travels, published in 1880. In 1894, he provided a community instate endowed with some 1,600 books for Fetterangus, his home town in Scotland. In 1891, he published a collection of hymns for the use of the congregation, much as Goodwyn Barmby had done in 1860. In 1901 he produced

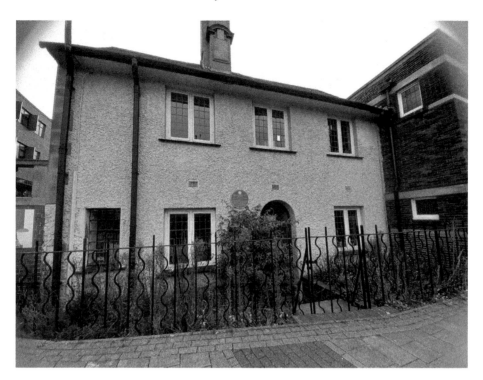

Above: The former home of the John Goodchild collection beneath the Andrew Carnegie Library on Drury Lane, an essential place of pilgrimage for anyone interested in the history of the city of Wakefield.

Right: Nellie Spindler, a Wakefield lass who died aged just twenty-five on 21 August 1917 in Passchendaele, Belgium. She served as a nurse at No. 44 Casualty Clearing Station (CCS) at Brandhoek during the First World War. Though about 7 miles from the front lines, Brandhoek was within range of the larger German guns, and with its railway sidings and munitions dumps was the target of frequent German shelling. Indeed, she was killed when the sidings were shelled. A blue plaque was erected to her memory, and a road named in her honour.

a collection of litanies and chants, with music set by Jeremiah Dunnill for the congregation at Westgate. In 1906 he organised the restoration of the Westgate End cemetery. He retired in 1909 and returned to his native Scotland. For some years previously, he had been chaplain to the chairman of the West Riding County Council, chapel president Sir Charles Milnes Gaskell. Chalmers died in 1912 aged seventy-one.

Wakefield was the home of Dr John Radcliffe, surgeon to King William III and Queen Mary. He was the son of George Radcliffe and Anne Loader, and was baptised on 23 January 1653 at All Saints Parish Church. He was educated at Queen Elizabeth Grammar School and thence at Northallerton Grammar School. He graduated from the University of Oxford, where he was an exhibitioner at University College tutored by Obadiah Walker, to become a Fellow of Lincoln College. He obtained his MD in 1682 and moved to London shortly afterwards. There he enjoyed great popularity, and died relatively young

This seventeenth-century building, tucked away off the Bull Ring, was the birthplace and home of Dr John Radcliffe. At the end of the eighteenth century it was home to publisher and radical politician John Hurst.

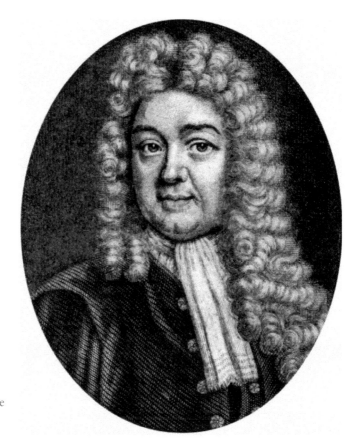

Dr John Radcliffe, one
of Wakefield's most
important sons.

in 1714. He was elected MP for Bramber, Sussex, in 1690 and in 1713 Member
of Parliament for Buckingham. On his death, his property was bequeathed to
various charitable causes, including St Bartholomew's Hospital and University
College, Oxford, where the Radcliffe Quad is named after him. The trust
founded by his will of 13 September 1714 still operates as a registered charity.
A number of landmark buildings in Oxford, including the Radcliffe Camera
(in Radcliffe Square), the Radcliffe Infirmary, the Radcliffe Science Library,
Radcliffe Primary Care and the Radcliffe Observatory, were named after him.
The John Radcliffe Hospital, a large tertiary hospital in Headington, was also
named after him.

The home in which Radcliffe was born still stands, though greatly altered. At
the end of the eighteenth century it was home to John Hurst, a notable publisher
and radical politician. It was Hurst who championed the publication of Richmal
Mangnall, a pioneering woman poet and author who lived at Crofton near
Wakefield, where she ran Crofton Academy. It was also from Hurst's printing
press that handbills promoting the abolition of the slave trade, denunciations of
the government during the 1790s and for peace petitioning in 1801 appeared,
which landed Hurst gaol time in York Castle for sedition. He was gaoled along

with Robert Bakewell and Revd Thomas Johnstone. Bakewell was a rabble-rousing speaker, who almost single-handedly organised the Wakefield petition for peace of 1801, and again that of 1807. A friend of Thomas Jefferson, several letters between the two men exist. In 1808 he published a treatise on wool; he had been a partner in the Healey Mill Company at Ossett from 1794, and in 1805 established his own steam powder factory to process fleece into cloth on Westgate Common, the site today being where St Michael's Church is. His book on wool was hugely important and the seminal treatise of the nineteenth century. Due to his unpopular politics in wanting to make peace with Napoleon and also unfavourable trading conditions, Bakewell went bust in 1810 and left the town soon after, leaving his assets in the hands of seven trustees, all members of Westgate Chapel. On moving to London, Robert worked as a geological consultant, assisting landowners to exploit mineral resources on their properties. He was also a peripatetic public lecturer, and he lectured on geology at Manchester in 1811 (he published a geology of Manchester in 1814). In 1813 he published *An Introduction to Geology*, which provided a introductory guide to the geology of Great Britain; this was very successful and went through five editions.

Bakewell enjoyed considerable influence as a geologist – both Charles Lyell and Adam Sedgwick acknowledged his work. He allowed these men to understand 'deep time' and that the earth was older than 4004 BC and had evolved and changed. This was only possible through Bakewell adopting his wife Apphia's Unitarian faith. Apphia's influence on the understanding of geology and evolution cannot be underestimated.

Bakewell stressed the practical value of geology, and he was critical of other geologists who he considered overemphasised Continental theorists such as Abraham Gottlob Werner; this earned him the disapproval of some members of the Geological Society, and he never became a member of this body. In 1819 he published *An Introduction to Mineralogy*, which was addressed to a non-specialist audience. Bakewell continued to publish on geology in the 1830s, composing the geological sections of J. R. Macculloch's *Statistical Account of the British Empire* (1837). He died at his home in Hampstead, London, in 1843.

Making his home in Wakefield was Cheesman Henry Binstead. Born in Portsmouth in 1798, the second of three sons born to Edward Binstead, he joined the Royal Navy as a 'First Class Volunteer' on 10 June 1810. 'First Class Volunteers' tended to be boys, around twelve or thirteen years of age, taken on by a ship's captain as a favour, or to curry favour with an influential family, almost as a sort of apprenticeship before sitting an examination as midshipman. As a 'First Class Volunteer' Binstead was on the first rung of a career as a naval officer and after thirty years' service was promoted to the rank of Commander on 23 November 1841. Placed on half pay in 1843, in 1844 he moved to Wakefield to take up the position as 'Outdoor Superintendent' of the Manchester & Leeds

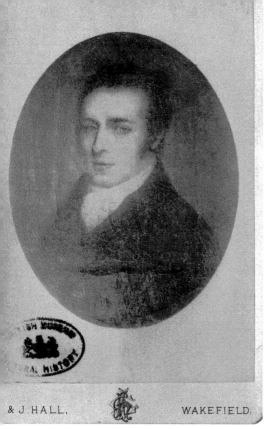

Above left: Robert Bakewell, an adopted son of Wakefield, whose importance in the study of geology cannot be underestimated.

Above right: The South Parade home of Cheesman Henry Binstead, Admiral in the Royal Navy and senior manager of the Lancashire & Yorkshire Railway.

Railway, renting a modest town house at No. 100 Northgate. His office was at Wakefield Kirkgate station. As 'Outdoor Superintendent' he was tasked with the day-to-day operations of the railway. Binstead would remain as General Superintendent of the 'Eastern Division' of the Lancashire & Yorkshire Railway from 1849 until his retirement in 1871. Binstead was awarded the Silver Medal of the Royal Humane Society in December 1850 for having jumped in the River Calder – whilst fully clothed (and at the age of fifty-three) – to rescue a young girl, Ellen Farrell, who had fallen in and was in danger of drowning. He took an active role in Wakefield's social life, attending the many charity balls. He was a patron of the Wakefield Industrial and Fine Arts Exhibition; in 1859 he was appointed Secretary of the Wakefield Rifle Volunteers, and from 1870 a patron of Wakefield Rowing Club and its annual regatta. The news of Binstead's promotion to Rear Admiral in 1870 was met with great adulation in Wakefield, and in August that year he became a Deputy Lieutenant of the West Riding. The old Admiral died at his home in South Parade on 26 November 1876. His closing years were, as his obituary commented, sad and lonely having outlived his wife and his only son.

The home of Clara Clarkson, whose legacy to Wakefield is her series of diaries.

His health had been slowly failing, but despite a bad case of jaundice he had still been active and had 'only taken to his bed until the last few hours of his life'. He had been, wrote the *Wakefield Herald*, 'a strict disciplinarian' and 'in private he was forever actuated by a desire to do well'. To those who did not know him he appeared 'indifferent' and 'old fashioned'; 'scrupulous in his duty' and 'kind-hearted to a fault', Binstead was a well-known and respected figure in his adopted town. His funeral took place at St John's Church. His coffin, draped with a Union Flag, was carried by six of the oldest stationmasters who had worked under him.

Clara Clarkson was born into an apparently wealthy Unitarian family in 1811. Her father, Benjamin, was a lawyer of 'dubious character'. One of three children, her brother, Alfred, was, it seems, murdered and her sister died of disease as a teenager. As one of only eleven women who signed the very first Women's Suffrage petition, Clara Clarkson was one of Wakefield's most prominent advocates for women's rights. Her legacy is the diary *Merrie Wakefield*, which has been republished by Dream Time Creative. Clara, along with her domineering mother and brother, lies buried in Westgate Chapel yard.

Kate Taylor was one of the foremost historians of Wakefield. Coral 'Kate' was one of three daughters of George Taylor, a manager for the national grid, and his wife Dora. Educated at Wakefield Girls' High School in the same class as the author's great-aunt, Kate went on to study English at St Anne's College, Oxford. During her vacations she worked as a freelance journalist for the *Yorkshire Post*, interviewing Kingsley Amis, Iris Murdoch and John Braine. She graduated, but pregnancy forced her home, 'irretrievably alienated from the baby's father', as she put it. Defying parental and social pressures, she struggled through the 1960s and 1970s as a single parent. She became a teacher, first in secondary schools and then at teacher training colleges in Leeds and Barnsley. In 1978 she became vice-principal at the new Barnsley Sixth Form College. Later she worked for the Open University, lecturing to inmates in the high-security HMP Wakefield. She was an effective teacher, but journalism constantly beckoned. During European Architectural Heritage Year (1975), Kate was the press officer for Wakefield Heritage Committee, formed to organise local celebrations, for which she wrote a series of articles on church buildings.

After becoming a Unitarian, attending Westgate Chapel, Kate worked for the 'General Assembly of Unitarians and Free Christians 'as a press officer for many decades and was a frequent contributor to their newspaper, the *Inquirer*. Kate was also a member of the Unitarians' penal affairs panel, working to improve prison education and on issues affecting women in prison. For many decades, Kate was the organist at Westgate Chapel - a position she vacated to the author in 2012 - and oversaw the restoration of the chapel's organ. Kate was central to the life of Westgate Chapel as trustee, secretary and president.

Kate worked as an author and editor on many publications about Wakefield, including *More Foul Deeds and Suspicious Deaths in Wakefield* (2003), *The Making of Wakefield* (2008), and two volumes of Wakefield District Heritage. In 2005 her frank autobiography, *Not So Merry Wakefield*, was published documenting, among other things, her difficulties as a single parent. As a result of her final book, *Wakefield Diocese: Celebrating 125 Years* (2012), she was made a lay canon of Wakefield Cathedral.

As chairperson, secretary-treasurer and fundraiser for Friends of the Chantry on Wakefield Bridge, she produced a booklet telling its story. She was president of the Wakefield Historical Society, and became editor of its journal, supporting campaigns to retain significant buildings. Kate was for a time also president of Wakefield Civic Society, a member of Wakefield Historical Publications and of the Gissing Trust, which runs a small museum. After her funeral, held at Westgate Chapel, it emerged that Kate's name had appeared in the Queen's birthday honours list for 2015, with an appointment as MBE for services to heritage and to the community in Wakefield. The honour was received on her behalf by her son, Simon, who survives her along with a sister, Enid, and a grandson, Barnaby.

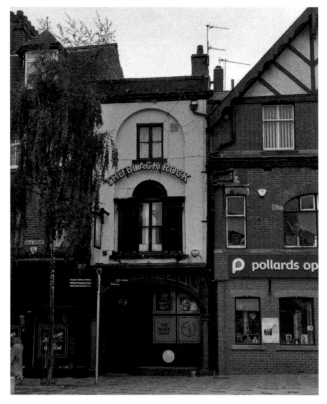

The late eighteenth-century Black Rock public house stands on the site of the house where John Potter lived as a child. He was to be Archbishop of Canterbury from January 1737 until his death in 1747. He was the son of a linen draper in Wakefield. At the age of fourteen he entered University College, Oxford, and in 1693 he published notes on Plutarch's *De audiendis poetis* and Basil's *Oratio ad juvenes*. In 1694 he was elected fellow of Lincoln College, Oxford, and in 1697 his edition of Lycophron appeared. It was followed by his *Archaeologia graeca* (2 vols, 8vo, 1697–1698), the popularity of which endured until the advent of Dr William Smith's dictionaries. A reprint of his Lycophron in 1702 was dedicated to Graevius, and the Antiquities was afterwards published in Latin in the *Thesaurus of Gronovius*.

Besides holding several livings, he became, in 1704, chaplain to Archbishop Tenison, and shortly afterwards was made chaplain-in-ordinary to Queen Anne. From 1708 he was Regius Professor of Divinity and canon of Christ Church, Oxford, and from 1715 he was Bishop of Oxford. In later years his edition of *Clement of Alexandria* appeared. In 1707 he published a *Discourse on Church Government*, and he took a prominent part in the controversy with Benjamin Hoadly, Bishop of Bangor. Even though Potter was a notable Whig, he was a High Churchman. It was also Bishop Potter who ordained John Wesley a deacon in the Church of England in September 1725, and a few years later ordained him a priest in 1728.

In January 1737 Potter was unexpectedly appointed to succeed William Wake in the see of Canterbury. He married Elizabeth Venner, a granddaughter of Thomas Venner, who had been hanged as a traitor. Potter died on 10 October 1747. His theological works, consisting of sermons, charges, divinity lectures and the discourse on Church government, were published in three volumes. Published in 1753, Potter's *A System of Practical Mathematics* is a comprehensive reference work which, amongst other topics, addressed aspects of astronomy and the recently adopted Gregorian calendrical system. He was buried in Croydon Minster in Surrey.

Above: Joseph Aspdin (or Aspden) was the eldest of the six children of Thomas Aspdin, a bricklayer living in the Hunslet district of Leeds, Yorkshire. He was baptised on Christmas Day 1778. He entered his father's trade, and married Mary Fotherby at Leeds parish on 21 May 1811. By 1817, he had set up in business on his own in central Leeds and on 21 October 1824 he was granted the British Patent BP 5022 entitled 'An Improvement in the Mode of Producing an Artificial Stone', in which he coined the term 'Portland cement'. Almost immediately after this, in 1825, in partnership with a Leeds neighbour, William Beverley, he set up a production plant for this product in Kirkgate, Wakefield, which remained in operation until 1838 and established premises on Ings Road, where it remained until 1900. Joseph Aspdin died on 20 March 1855, at home in Wakefield. To mark the centenary of the patent, handsome memorial gates were erected outside St John's Church.

Right: Ann Clarkson was a Unitarian whose brother was the more famous Henry. She worked tirelessly throughout her long life for the welfare of animals, and founded a precursor organisation to the RSPCA in Wakefield. In 1870, she and her minister, Revd J. G. Barmby, founded the Wakefield branch of the RSPCA.

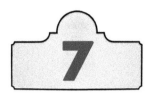

A World Heritage

Since the 1690s, Wakefield has been home to immigrants: the Busk family came from Switzerland; Mary Anne and Rachel Busk married into the influential Milnes family. Coming from Saxony was Christian Frederick Gotthardt, born in Meersburg in 1732, who lies buried in the grounds of Westgate Chapel. Other families from Germany moved to Wakefield: the Hofmann and Hagenbach families were perhaps the most prominent. Sadly in the Frist World War the businesses and homes of these families were attacked, and the male members of the families put in prison. Members of my own were imprisoned in 1914 as 'illegal aliens'. Coming from Portugal and playing a major role in the development of Wakefield were the Fernández family, so too the Thomsons. The O'Dwyer family of educationalists came from France. All made a distinctive addition to the town.

The Dutch slave-owning Peterson family – after whom Peterson Road is named – came to Wakefield in the 1780s. By the 1860s Wakefield was home to a family born in India: the Boshazadin family, who attended Westgate Chapel in the 1860s. Almshouse Lane brass foundry was run by the Brown family. They were the descendants of freed slaves and are one of the first black families in the town. We know persons of African heritage lived in Wakefield in the eighteenth century, alas owned as slaves by Thomas Charnock and Robert Prescott.

Many from Ireland arrived in Wakefield in the 1840s and settled in the now long-demolished houses on Union and Nelson Street. One early arrival from Ireland was Catherine Carr from County Carlow. She died in 1806 and lies in the catacombs beneath Westgate Chapel. Immigrants to Wakefield have not always been welcomed sadly, both now and in the past.

In August 1862 Baron de Camin, an uncompromising anti-Catholic slanderer, toured the industrial towns of the West Riding. The agitation and bitterness he helped kindle succeeded in stirring up tensions between the English and Irish. On 23 August 1862, at Wakefield, several hundred Irishmen, led by Revd John Baron, a Catholic priest attached to Wakefield Prison, marched on the Theatre Royal, Westgate, to prevent Baron de Camin from making a public appearance. However, there was no chance of him appearing because the agent refused to open the theatre doors. Unfortunately for Baron de Camin, he was spotted by a

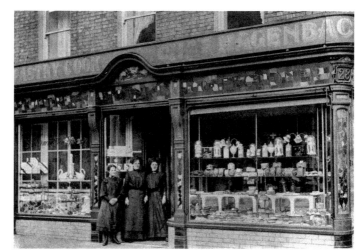

The premises of the Hagenbach family. As German immigrants their shop was attacked during the First World War, as the family were seen as traitors.

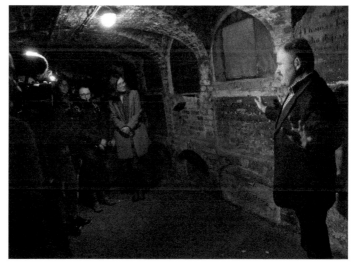

The catacombs beneath Westgate Chapel are perhaps the oldest such spaces for burial in the north of England. The catacombs are the last resting places of four MPs, as well as freemasons, diarists, a privateer, a minister of religion, as well as children and those involved in the woollen trade.

number of Irish protesters in Silver Street, and had it not been for the protection afforded him by the mayor and the police he would probably have been seriously injured. Sadly, on the following evening, however, what amounted to a religious riot occurred outside the Royal Hotel, where Baron de Camin addressed a large English audience from the hotel's balcony. In his address, the Baron called on his Protestant audience to 'Remove all Catholics'. As a consequence he was immediately removed from the balcony by the attendant police officers for inciting violence. Taking his words literally, many Protestants made their way into the Nelson Street area of the town, an Irish district, and began smashing windows and assaulting any Irish residents who had dared venture into the streets. Because the Baron had also raised the cry of 'Down with Nunneries', the Protestant mob made their way to St Austin's School, the home of the Sisters of Charity, and smashed the school's windows. The mob then moved a short distance to St Austin's Church and smashed the windows there. The mob also assaulted the local priest, Father Wattriel. Thankfully such outbursts of religious intolerance have not been witnessed since.

In the 1940s a large Italian population grew up in Wakefield followed by immigrants from the Caribbean and also India and Pakistan. Most of the men in Wakefield worked in textiles, in mills such as Rawson's and Albion Mills. The first shop to cater for the Pakistani community in Wakefield opened on St Catherine's Street in Agbrigg run by Rashid Mughal, or Sufiji as he was known. As well as providing the spices and vegetables people wanted, the shop had another important role to play – helping people to keep in touch with family back in Pakistan. In the 1950s and 1960s there were no facilities in Wakefield for the Pakistani community to practice its Islamic faith. People gathered in houses to pray and Eid prayers even took place in nightclubs and, on one memorable occasion in the mid-1960s, in Wakefield Cathedral. It was decided the community needed a mosque and the Wakefield Mosque Fund was set up.

St Austin's Church, Wentworth Terrace, was completed in 1827, having been built by William Puckrin, who had also built parts of nearby St John's North. In 1878–79 Joseph Hansom, architect and inventor of the Hansom cab, remodelled the church.

The group agreed to buy St Michael's School on Grange Street for £2,000. They then faced a lengthy battle with Wakefield Corporation, who refused planning permission to convert the school into a mosque. Eventually the group overcame the Corporation's objections, and in 1974 set about creating the Markazi Jamia Mosque Wakefield, the city's first mosque. In more recent years Polish, Latvian and Eastern European people have made Wakefield their home, imbuing Wakefield with a wonderfully rich and diverse culture.

As well as welcoming people from across the globe, Wakefield men and women have travelled far and wide.

Adopted son of the city Robert Prescott was a professional soldier. During a military career which spanned over fifty years, he participated in the Seven Years' War, the French and Indian War, and the American Revolutionary War, including key engagements such as the Montreal Campaign. He later became the Governor of Martinique and then, in 1796, Governor General of The Canadas, and the British Army's Commander-in-Chief for North America. He was recalled to England in 1799 after conflict with the Catholic Church and disputes with Anglo-Canadian colonial elites over the distribution of land in the colonies. He continued to hold his position until 1807, with his lieutenant governors acting in his absence. He died aged eighty-nine in 1815 after unsuccessful attempts to clear his name. He married the daughter of William Serjeantson in Wakefield in 1762, a witness to the marriage being Hannah Milnes, whose young brother Robert would come under Prescott's patronage. Susanna Prescott's (née Serjeatonson) brother William died soon after and his widow would marry Benjamin Heywood of Westgate Chapel in 1782. Thus, Prescott became interalia a member of the Milnes-cum-Heywood family. In February 1764 the vicar sought permission for the baptism of a young black man of over twenty who 'belongs to Colonel Prescott':

Wakefield February 18 1764

May it please Your Grace,
 There is a young Man, a Black, above twenty years of Age, who has given notice to my Curate Mr Armitage that he desires to be baptized.
 He belongs to Colnel Prescot, who now resides in this Town. I wish Your Lordship and all your Family good Health and I am, my Lord,
 Your Lordship's most Obedient and most Humble Servant

Benjamin Wilson

The word 'belongs to' leaves us in no doubt that he was a slave and the personal property of the Colonel. Prescott was no different to a lot of others of the era. In October 1793 promotion to General came and he was ordered to become military commander of Barbados, where he was awarded slave plantations. He was involved in the capture of Martinique and named governor, and was again rewarded with more

slaves by a grateful British Crown. Appointed lieutenant governor of Lower Canada on 21 January 1796, he was succeeded in Martinique by Robert Shore Milnes.

Milnes' father and brother John lay in the catacombs beneath Westgate Chapel, where he was baptised. After a military career in the Royal Horse Guards, Milnes left the army in 1788 with the rank of captain. Seven years later he was governor of Martinique. On 4 November 1797 he was appointed lieutenant governor of Lower Canada, and on 15 June 1799, at fifty-three years of age, he was sworn in. A baronetcy was conferred on him on 21 March 1801. Milnes left for England on 5 August 1805, along with his brother John and his family,

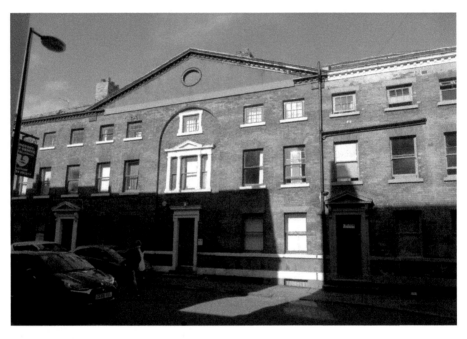

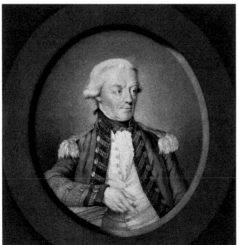

Above: This handsome town house in Barstow Square was the home of an adopted son of the city, Robert Prescott.

Left: Robert Prescott, army officer, slave owner and deputy governor general of Lower Canada, and then governor of Martinique after its conquest by the British Crown in the 1790s.

but remained administrator until 12 August 1805. Thomas Dunn assumed his duties as administrator until Governor Sir James Henry Craig arrived in October 1807. Milnes acted as agent for Martinique from 1809, working under Governor General Broderick and his successor Governor Wale for a number of years and was noted for his enlightened governance. He took up the cause of both the Creole Elite, as well as French freed slaves and French nationals. The slave revolt in 1811 was Milnes' greatest moment of triumph. With no access to international markets to trade sugar and other goods, the island's economy collapsed. Recognising that the island's economic distress connected directly to its racial imbalance and racist culture, Milnes warned that continued economic stress may lead to larger slave revolts, invoking the spectre of the Saint Domingue rebellion. Driven by famine, the possibility of a West Indies-wide rebellion was strong unless the British government allowed the French plantation owners to sell their coffee and sugar in home markets in France. The British government, of course, ignored Milnes, refused to grant Creoles British status as subjects of the Crown and refused to allow Martinican ships into home ports. Milnes managed to keep 'the lid' on rebellion, but matters were made worse by a devastating hurricane in 1813 which witnessed Milnes petitioning the home officer for aide, and the government in London finally allowed Martinican ships to trade their sugar into British ports. He was named a trustee of Westgate Chapel in 1774 and was president from 1812 to 1837; his two daughters became the first female trustees in the chapel's history. He married Charlotte Frances Bentinck, daughter of Captain John Bentinck and Renira van Tuyll van Serooskerken, on 12 November 1785. Milnes died at Tunbridge Wells on 2 December 1837 and was survived by two daughters and three sons. Two sons were army officers: John Bentinck Milnes was killed in the war of 1812 and William Henry Milnes was killed at the Battle of Waterloo. Mrs Milnes died in 1850. Robert's sister, Hannah, was a celebrated beauty and mistress of the Duke of York and also Robert Wedderburn, as well as John Lee, attorney general.

Heading to Australia were the daughters of the slave-owning vicar of St John the Baptist Parish Church. Fidela Hill (née Munkhouse), pioneering Australian poet, claimed for part of the compensation for Strawberry Hill in Port Royal, Jamaica, with her husband Robert Keate Hill. The couple moved to Jamaica 'shortly after' their wedding to oversee their slave plantation. In the mid-1830s they travelled to Australia 'on the understanding that Robert Hill would be given a position in the new colony of South Australia'. They were in Adelaide from 1836 to 1838, then, Hill having died, Fidelia remarried in Tasmania, where she died in 1854. Hill's *Poems and Recollections of the Past* (Sydney, 1840) was the first volume of poetry by a woman published in Australia.

Heading to America was Twistleton Haxby, a lawyer and businessman who invested in Chilean silver mines. When gold was found in California, Martin Wormald from George Street, along with John Hawker Baldy, George Dear and Mary Jameson, all headed off to find their fortune.

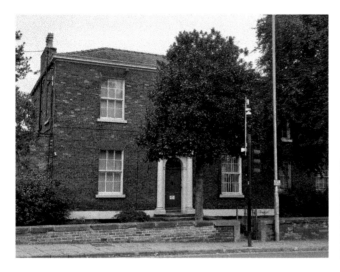

St John's Lodge, built by cloth merchant David Smirthwaite, was the home of Chilean silver mine owner Twistleton Haxby from 1827 until his death in 1844.

Today, the city provides jobs in the bar and leisure industry, as well as the IT or service industry. Recent development has seen the new shopping mall of Trinity Walk laid out, a new urban centre at Merchant Gate betwixt Westgate and Balne Lane, as well the impressive £35 million The Hepworth Wakefield, named in honour of local sculptress Barbara Hepworth, which opened in May 2011. Commencing in 2017 the City Fields development, spanning 375 hectares, is set to change Wakefield on a grand scale.

Above and opposite above: The Art House, housed in the former Carnegie Library on Drury Lane, is the crowning glory of Wakefield's art scene. The Art House provides time, space and support for artists, makers and creative businesses to develop their practice. It is a place where artists and audiences of all kinds are welcome to engage with the creative process through a year-round programme of exhibitions and events.

Above: As part of the redevelopment of the former Wakefield Gas Works complex, a new shopping mall was planned, and work began in 2008. The scheme was on the verge of failure in March 2009, but the idea was resurrected in 2010 and the mall finally opened on 6 May 2011. Wakefield Council describe it as 'the most important City Centre development for more than 20 years'.

Right: Wakefield is home to artisan cafés and bars, often found tucked away in hidden alleys, as here on George and Crown Yard.

Left: Old homes have been repurposed into retail spots and bespoke restaurants. On Northgate, a Tudor town house is the setting for an independent eatery.

Below: The former banking premises of Leatham and Tew, founded in Wakefield as Milnes, Leatham and Tew, have become one of the city's most fashionable destinations for an evening meal.

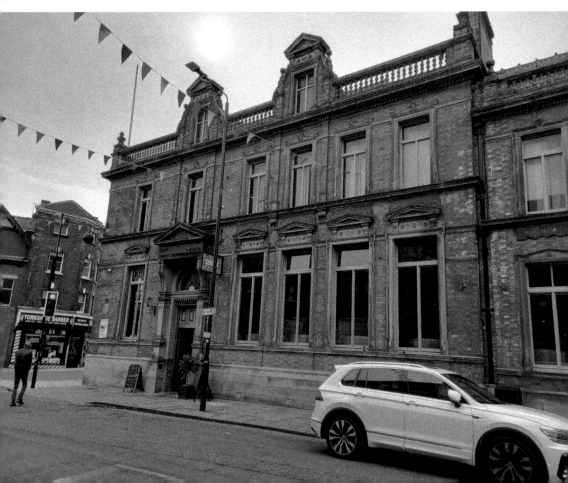

Despite the almost wholesale destruction of Wakefield's heritage buildings since the 1950s, older buildings do remain. One of the oldest brick buildings in the city, dated 1727, hides in plain sight on Bread Street.

Above: The Hepworth Gallery pays homage to one of Wakefield's most famous daughters.

Right: At the heart of Wakefield for a 1,000 years, give or take, Wakefield Cathedral stands sentinel over the changing cityscape.

Further Reading

The bulk of this book is based on contemporary newspapers as well as extensive notes and MSS sources held by the late John Goodchild M.Univ. The following books by the author, published by Amberley Publishing, may be of interest to readers: *Wakefield at Work, Wakefield: A Potted History* and *A–Z of Wakefield*. Also of reference is my book *Wakefield Memories*, as well as *The Battle Against Slavery*, printed by Frontline Books. In addition, the following are highly recommended:

Dawson, Jane, *The Sanitary Conditions of the Working-Class People of Wakefield 1830–1870* (BA (Hons) Thesis, Leeds Metropolitan University, 1997)

Goodchild, John, *Aspects of Medieval Wakefield* (Wakefield Historical Publications, Wakefield, 1991)

Taylor, Kate (ed.), *Worthies of Wakefield* (Wakefield Historical Publications, 2004)

Taylor, Kate, *The Making of Modern Wakefield* (Wharncliffe, Barnsley, 2008)

Taylor, Kate (ed.), *Wakefield and District Heritage* 2 vols (Wakefield EAHY Committee, 2008)

Taylor, Lesley, and Levon, Shirley, *The Two Esthers, Letters from Mrs Robert Milnes of Sheffield and Wakefield to Esther Milnes of Chesterfield 1771–1773* (Taylor Levon Press, Wakefield, 2014)

Taylor, Thomas, *The History of Wakefield in Yorkshire* (W H Milnes, Wakefield, 1886)

Walker, J. W., *Wakefield, Its History and its People* (Privately Printed, 1934)

The Forgotten Women of Wakefield project, notably Helga Fox, have proved most useful in answering queries.